The Art of
AIRBRUSHING

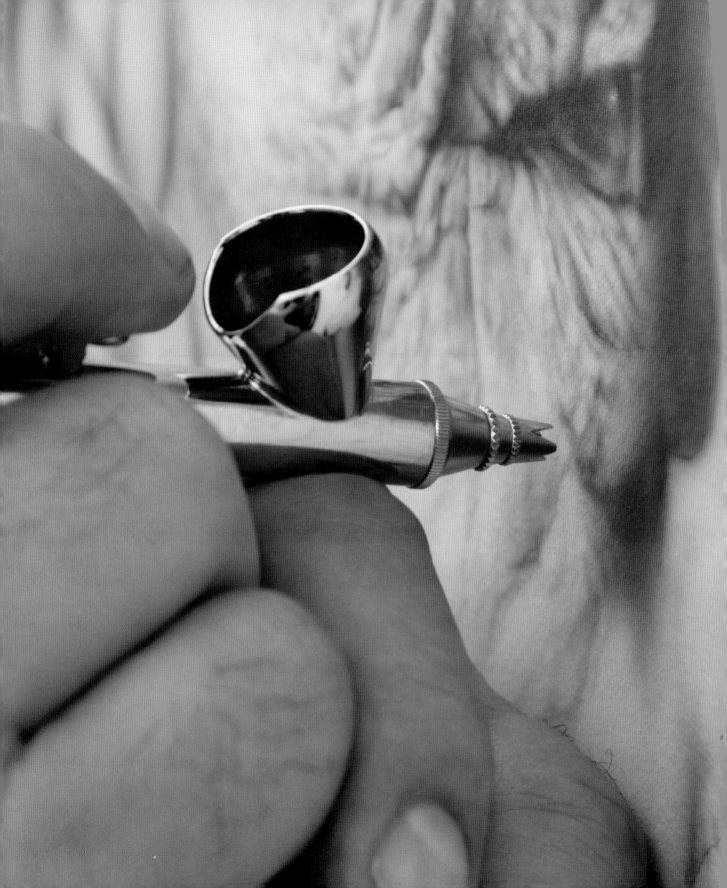

The Art of

AIRBRUSHING

A SIMPLE GUIDE TO MASTERING THE CRAFT

Giorgio Uccellini

First published 2011 by
Guild of Master Craftsman Publications Ltd
Castle Place, 166 High Street, Lewes,
East Sussex BN7 1XU

ISBN 978 1 86108 830 7

A catalogue record for this book is available from the British
Library.

Publisher **Jonathan Bailey**
Production Manager **Jim Bulley**
Managing Editor **Gerrie Purcell**
Editor **Beth Wicks**
Managing Art Editor **Gilda Pacitti**
Designer **Ginny Zeal**
Photographer, Photo Editor and Copywriter **Marco Uccellini**

Set in Goudy and Helvetica Neue
Colour origination by GMC Reprographics
Printed and bound in China by Hing Yip Printing Co. Ltd.

Contents

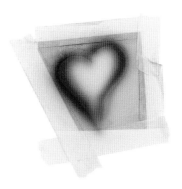

SECTION ONE
Getting started

Tools and equipment

Techniques

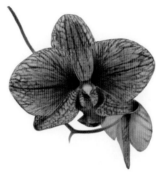

SECTION TWO
The projects

Textiles

Canvas and art paper

Metals

Wood

Composite materials

History and introduction

The purpose of this book is to pass on my many years of experience in the art of airbrushing and to promote this craft by giving others the various skills and the confidence to pick up an airbrush and give it a go.

The many varied projects offer a range of surfaces on which to work and will demonstrate to the first-time user or long-term expert the many different ways that an airbrush can be employed. Each project shows in detail how to use various techniques to create your own artistic masterpieces. With lots of practice and perseverance, you will go on to develop your own unique style.

From the book A Manual of Airbrush Techniques *by J. Carroll Tobias, published 1941*

The book is full of information and techniques that I have collected together over many years. Completing all the projects will enable you to become a proficient airbrush artist and will demonstrate that the airbrush is a highly versatile tool capable of producing artwork that is comparable to any other traditional artistic medium.

A historic overview

Airbrushing has been around for over a hundred years. The first modern type of airbrush was invented by Charles Burdick and presented in 1893 at the World Columbian Exposition held in Chicago. Burdick used his airbrush to paint using watercolours and was the first artist to have an airbrushed painting accepted by the Royal Academy of Arts in London. His prototype airbrush was similar in appearance to a pen and worked just like a modern airbrush, using the same formula of compressed air to atomize the paint flowing over a very fine needle. The body shape has remained relatively unchanged over the years. Modern airbrushes still look like pens with a lever in the middle and a reservoir at the front.

Initially, airbrushing was mainly used to retouch photographs, then for poster and glamour art in the 1930s and 1940s. At the same time, painted silk ties were being mass-produced for the American retail market. The majority of these ties were painted with a brush, but the ones that captured the most attention were those that had been airbrushed by true craftsmen. These airbrushed ties were totally unique and are still frequently sought after by collectors.

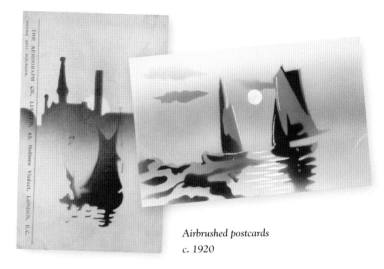

Airbrushed postcards c. 1920

In the 1960s, Big Daddy Roth used the airbrush to customize T-shirts which became increasingly popular throughout America. During the 1970s, several artists including Chuck Close, Don Eddy and Audrey Flack took up airbrushing. Together they started the Photorealist movement in America in which realistic artwork was created using photographs as reference material. Hyperrealist artists took Photorealism a step further to create highly detailed renderings that are often impossible to distinguish from paintings.

The airbrush is now firmly entrenched in the art of today and is beginning to be accepted as an art form in its own right.

A selection of airbrushed silk ties c. 1940

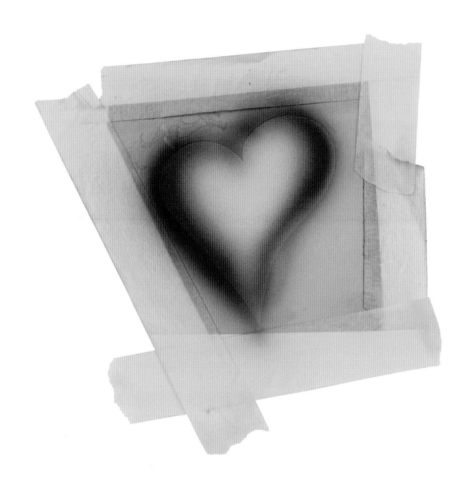

Getting started

Explore the many different tools and materials used in airbrushing; try your hand at the various techniques to fine tune your skills and create your own unique artwork. The following section outlines everything you need to know to become proficient in the art of airbrushing.

TOOLS AND EQUIPMENT

Airbrushes

The airbrush is a mechanical instrument that converts paint in a reservoir into a very fine spray. High-pressure air is supplied to the airbrush by a compressor. This fast-moving air causes the paint to atomize into very tiny droplets that are then carried to the chosen media.

It uses a combination of two valves that allow the artist control of the spray. Pulling back on the trigger with the index finger controls the needle valve. This trigger action opens the valve and allows the spray to emerge from the nozzle. The air valve controls the volume of air entering the airbrush and therefore determines the amount of paint that is pulled from the reservoir. This valve is controlled by pressing down on the trigger with the index finger. The air pressure is set on the compressor and is determined by the thickness of the paint that is being used. In most cases this should be about the same consistency as milk.

It is important to get into the habit of airbrushing with the air valve open, as this provides a greater amount of fluidity whilst working. This will also prevent a build-up of paint being left in the nozzle when you stop spraying.

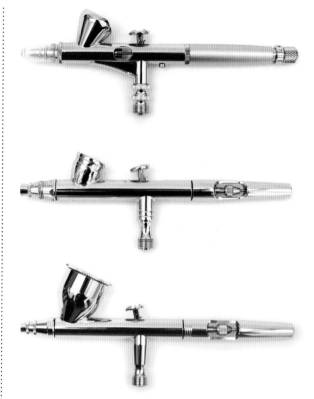

A variety of airbrushes: Iwata Custom Micron (top), JVR 2, Iwata Eclipse (bottom)

Iwata Eclipse airbrush with annotated parts

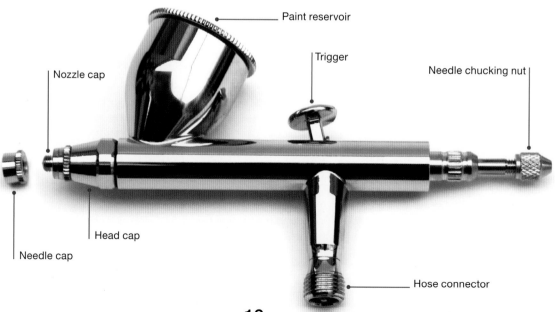

Paint reservoir

Trigger

Needle chucking nut

Nozzle cap

Head cap

Needle cap

Hose connector

12

If paint builds up in the nozzle it can easily splatter onto your work when you resume painting. The combination of air pressure and needle control gives the artist full control of the airbrush, allowing him or her to produce very fine lines on the chosen work surface with just a small amount of paint and pressure. The more the trigger is pulled back the more the valve is opened, allowing more paint to be drawn through the airbrush and vice versa. This allows the artist the flexibility produce a variable spray pattern.

Maintenance

The airbrush is a very expensive piece of equipment that will last a lifetime if it is looked after properly. It is essential that you always clean the airbrush after finishing a session of airbrushing and to ensure that paint is not left in the reservoir, as this will dry out and will need solvent to remove it properly.

Always flush the airbrush through with water or cleaner every time you finish working. Then remove and clean the needle, taking care not to bend it. After cleaning lubricate the needle and trigger with a lubricant designed specifically for the airbrush. If the airbrush stops working correctly and simple cleaning does not help, it will need to be sent to the authorized dealer for a service.

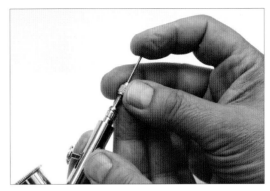

Locking the needle chucking nut

Replacing the needle

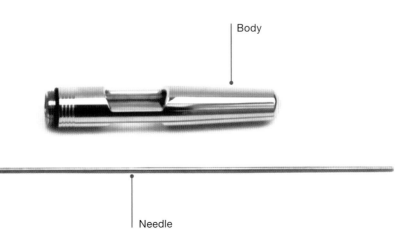

Body

Needle

Compressors

The compressor is the second most important item that you will need. The model you choose should be able to supply a steady air pressure of between 25 to 50psi for long periods of time; it should also be reliable and not too expensive. The models shown here are simple to maintain since they are oil free and only require periodic external cleaning. Compressors also need good air circulation at all times, so make sure that they are never covered over.

When the airbrush is switched on, the compressor fills the reservoir tank with air to a high pre-determined pressure. The tank is fitted with a regulator, connected to the air hose, which allows you to determine the air pressure required.

Modern compressors are silent and portable with a built-in moisture filter. This ensures that there are no adverse problems with moisture getting into the air hose. Moisture in the hose can cause the airbrush to spit water at the same time as the paint flows, therefore ruining your work.

As well as being clean and convenient to use, these compressors have a fitted safety valve to prevent an excess build-up of pressure and a thermal cut out if they should overheat. If this does happen, let the unit cool down before you restart it, ensuring that there is an adequate flow of air around the compressor.

When working with compressed air, always be careful not to spray the air onto your skin as the pressure can force paint particles and air into the skin.

Additional equipment

A selection of sketching pencils (HB to 2B) are required for sketching outlines of artwork onto white surfaces, whilst a white crayon is ideal for drawing on black surfaces. For metallic and acetate surfaces, fine-point marker pens are very useful and can also be incorporated into the artwork on items such as skateboards, shoes and metal.

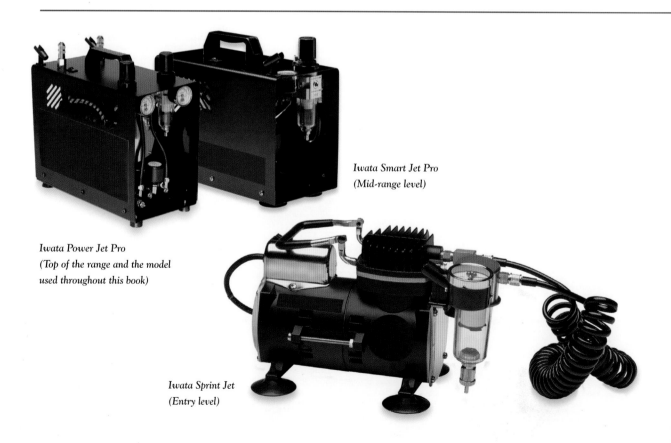

Iwata Smart Jet Pro
(Mid-range level)

Iwata Power Jet Pro
(Top of the range and the model
used throughout this book)

Iwata Sprint Jet
(Entry level)

You will also require a pair of sharp scissors and several scalpels for cutting masks. If you can afford a stencil burner it is well worth the expense, as this will allow you to cut plastic film stencils very quickly and accurately.

A set of good paintbrushes is also a requirement for mixing paint and for adding small highlights to your work. Very fine paintbrushes can also act as a tool to help clean the airbrush. Small plastic cups are sufficient for paint mixing, while an airbrush holder is necessary to hold your airbrush vertically when it is not in use, especially when there is paint in the reservoir.

When cleaning the airbrush, window cleaner works best. A few drops can also be added to acrylic paint to aid the flow of the paint while airbrushing. A glass jar is also handy to have as it can be used to pour any excess fluid into.

An opaque projector is also a very useful piece of equipment to aid with the transferring of photographs and drawings onto the surface to be painted. This technique will be detailed in the following section.

Media

The paints used in the projects in this book are all acrylic based. These newly formulated, fast-drying, polymer-based paints have a liquid consistency and can be easily thinned down with water, which makes them ideal for airbrushing. Their only drawback is the need to clean the airbrush immediately after every session. It is important not to use the less expensive tube acrylic paints as they will inevitably ruin the airbrush needles and nozzle, which are all very expensive to replace. Always use paints that are specifically manufactured for airbrushing.

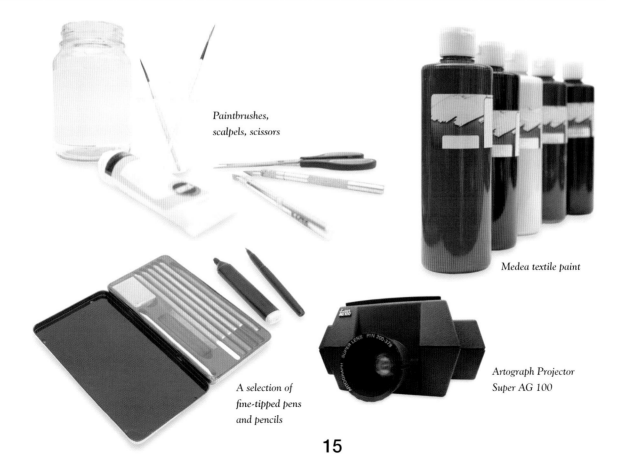

Paintbrushes, scalpels, scissors

Medea textile paint

A selection of fine-tipped pens and pencils

Artograph Projector Super AG 100

15

For most of the projects, Medea textile paints have been used. These are specially formulated to work on surfaces such as canvas, wood, and leather. They are also the best paints for use on textiles, especially T-shirts, since they provide vivid colour and the final artwork will last without fading, even after repeated washing. This range of paints also contains a very large selection of opaque and transparent colours, including metallic pearls and fluorescents.

Medea Colours have been used for the remaining projects. This paint range is particularly suitable for fine detail work and for use on both canvas and art paper. Medea also provides a large range of opaque and transparent colours.

For metal and plastic objects, JVR Revolution Kolor and JVR X Prof paints are the best choice. These work well on all surfaces, but are best suited for work that needs a protective coat of lacquer to be applied to the finished artwork, for example, custom artwork on crash helmets, motorbike tanks and car bodies. The coat of lacquer can also be polished to give a high-gloss finish and will certainly add a 'wow' factor to the final piece. However, lacquering requires skill and is therefore best handled by a professional car body shop.

JVR Revolution Kolor and JVR X Prof paints

Masking

When masking a particular area, beginners can achieve good results by using frisket plastic film, available in rolls or flat sheets. The plastic has a paper backing on it; once this is removed the film can be easily attached to the chosen surface. The film has a low-tack adhesive and can be safely removed from the surface after use. The sections of the work to be airbrushed are cut out and carefully lifted with the aid of a scalpel. The exposed area is then airbrushed by spraying up to and over the edge of the film. When the paint is dry, the cut pieces can be replaced to protect the painted area from over spray when you continue airbrushing. When masking a large area, use the film only on the section you are working on. Mask the remaining area with cheap paper fixed with masking tape to keep it in place while you work.

Using masks is another option. Loose masks can be cut out from either card or paper. These can be hand-held to produce soft edges or held down firmly to create sharper edges. The only downside to paper or card masks is that they can be used just a few times. If you need a mask that can be reused many times, acetate is ideal as long as you give the mask time to dry properly between uses. Acetate is a hard material to cut, so it is best to use a stencil burner as this will allow you to cut intricate reusable stencils quickly.

There are also many precut stencils on the market for the airbrush artist to choose from and which are useful aids for beginners. As a rule, any object that can be sprayed through will work as a form of stencil, so be creative and look around for things to try out.

Masking tape is also a great material to use as it comes in a variety of widths, anything from between ⅜in–11¾in (10–300mm) wide. Thin masking tape is ideal for following curves on crash helmets, motorbike tanks and car bodies.

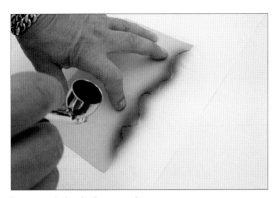

Loose mask, hard-edge example

Loose mask, soft-edge example

Charcoal filter mask

Face mask

Working environment

Ventilation

When working with an airbrush, ventilation is very important. Airbrushing produces atomized paint that is released into the air and can potentially be drawn into your lungs. To protect your health always ensure that you have a window open and/or an extractor fan installed. It is also advisable to wear an appropriate filter mask when airbrushing for long periods of time.

Lighting

The best light to work under is natural light. If this is not an option for any reason, the next best thing is fluorescent tube lighting used in conjunction with an artist's easel lamp fitted with a daylight bulb.

Fixed and loose-mask result

TECHNIQUES

Lines

Equipment:

- Iwata Eclipse airbrush
- Medea textile paint
- A4 paper
- Masking tape
- Ruler
- HB pencil

Straight lines

1 Fix a piece of A4 paper to the support on your easel with masking tape. Draw vertical guidelines on the paper at ⅜in (10mm) intervals with an HB pencil and ruler. Finally, add two vertical guidelines either side of the paper to show where to start and finish the airbrushed lines.

2 Load the airbrush reservoir with a few drops of your chosen colour of paint.

3 Position the airbrush between ³⁄₁₆–⅜in (5–10mm) from the paper and 2in (50mm) before the first line. Gently press down on the lever for air and begin to move your hand towards the guideline while slowly starting to pull back on the trigger. Continue across the page as you approach the end of the guideline. Remember, the closer the airbrush is to the page, the finer the resulting airbrushed line will be.

4 Let your finger move forward to cut off the paint supply but keep it pressed. When the paint has stopped spraying, release the trigger. Repeat these steps until you feel confident drawing freehand lines.

Wavy lines

Equipment:

- Iwata Eclipse airbrush
- Medea textile paint
- A4 paper
- Masking tape
- HB pencil

3 Continue spraying wavy lines following the first line with a ³⁄₁₆in (5mm) gap between each line until you have filled the sheet of paper.

1 With a pencil draw a wavy line on a piece of A4 paper to use as a guideline to follow whilst airbrushing. Then, load the airbrush reservoir with a few drops of your chosen colour of paint.

4 In order to give the illusion of shape and form to the wavy lines, try to imagine that light is coming from the left of the paper and hitting the front of the curve of the lines. This imaginary light would create a shadow on the opposite side of the curve. Spray very lightly from the top to the bottom of the curve.

2 Position the airbrush between ³⁄₁₆–³⁄₈in (5–10mm) from the page, then press the trigger for air. Begin to move towards the guideline whilst pulling back on the trigger. Follow the guideline to the end, allowing the trigger to move forward to stop the flow of paint.

5 Repeat the process until you are satisfied with the depth of the shadow.

Graduated tone

Equipment:

- Iwata Eclipse airbrush
- Medea textile paint
- A4 paper
- Masking tape
- Ruler

1 Take a piece of A4 paper and use masking tape to fix it on your easel. Use the tape to mask off and divide the area to be sprayed into three sections.

2 Load the airbrush reservoir with a few drops of paint. Position the tip of the airbrush approximately 2¾in (70mm) away from the paper. Press the trigger for air while pulling back to release the paint. Spray gently from right to left to produce a very light mist of colour, stopping after each line before continuing to work gradually down the page.

3 Start from the top of the paper again, but this time pull back further on the trigger to release more paint. Repeat the action in step 2 using several lines of spray to create a graduated tone from dark to light. It is useful to practise this technique, as it will help you when you begin to paint freehand portraits.

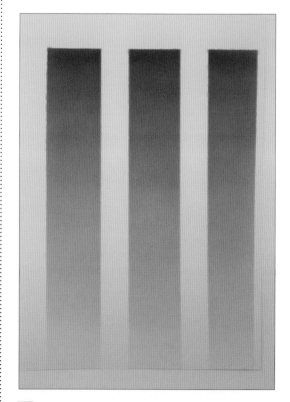

4 Remove the masking tape to see the result.

Dots

Equipment:

- Iwata Eclipse airbrush
- Medea textile paint
- A4 paper
- HB pencil
- Masking tape
- Ruler

2 Place a few drops of paint into the reservoir of the airbrush. Position the airbrush ⅜in (10mm) from the first intersection of a square and press the trigger for air. Gently pull back on the trigger for paint in a short burst to produce a single dot. To spray a larger dot, simply move the airbrush further back from the surface of the paper.

1 Take a piece of A4 paper and fix it to the support on your easel with masking tape. Then, with a ruler and pencil divide the paper into 1in (25mm) squares.

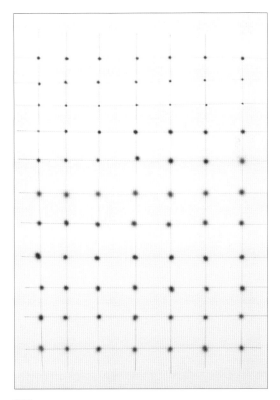

3 Continue until you have filled the whole page. Repeat the process, varying the size of the dots.

Shading and masking

Equipment:

- Iwata Eclipse airbrush
- Medea textile paint
- Masking film
- Frisket
- A4 paper
- Masking tape
- Craft Robo cutter
- Scalpel

Below are a number of basic shapes that can be used as stencils. These shapes are cut from masking film using a Craft Robo plotter. Alternatively, you can cut the stencils out of frisket or plain paper using a sharp scalpel.

Sphere

1 Place a piece of low-tack masking tape over the circle and film to hold it in place. Remove the backing paper and position the stencil on the paper. In order to protect the surrounding area from overspray, mask around the stencil with paper secured with masking tape.

2 Remove the cut-out circle from the stencil.

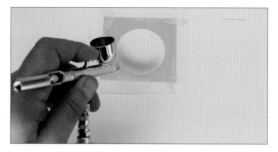

3 Place a few drops of black paint into the airbrush reservoir and decide where you want the virtual light to be positioned. The area that the virtual light is hitting will be the lightest and the other side will be in shadow and will therefore be the darkest.

4 Spray the dark area of the circle using semicircular movements, following the curve of the circle and going over the edge. Do not spray continually; instead, stop at the end of each stroke. Repeat this workflow until you are satisfied with the result. Then, go over the light area with a very gentle spray of colour. Finally, remove the masking paper and film and clean the airbrush.

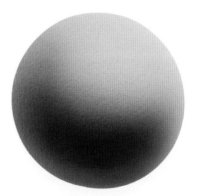

Finished sphere

Cone

1 Take a piece of A4 paper and fix it to the support on your easel with masking tape. Remove the paper backing from the film and position it on the surface to be airbrushed, A4 paper in this example. Mask around the edges of the film as before to protect the rest of the surface.

2 With the airbrush about 2in (50mm) from the surface, spray in straight lines down each side of the cone. Follow the edge of the cone on each side, leaving the centre the lightest to give the shape a three-dimensional quality.

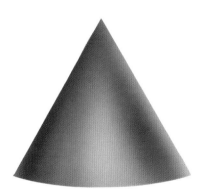

Finished cone

Cube

1 Place the masking tape over the cube to hold the stencil in place. Remove the paper backing and place the stencil film on the surface to be airbrushed. Mask around the stencil with paper to prevent any overspray getting onto the work surface.

2 Remove the right-hand face of the cube and decide where the virtual light is coming from. For this example, the virtual light source comes from the front of the cube.

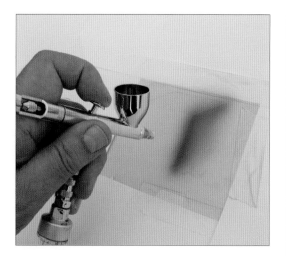

3 Place a few drops of black paint into the airbrush reservoir and begin spraying the exposed area of the stencil. Start close to the edge, then gradually move across the space in an up-and-down movement. The aim is to achieve a graduated black tone to make this first face and the top one the darkest. When you have finished, replace the mask carefully in its original position.

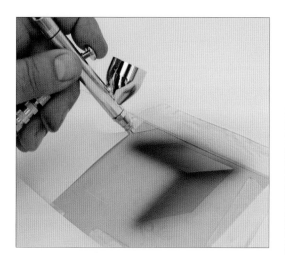

4 Remove the top face of the cube and airbrush it, first around the edges and then the exposed area until you have a smooth, graduated tone. There is no need to replace the cut-out mask for this area.

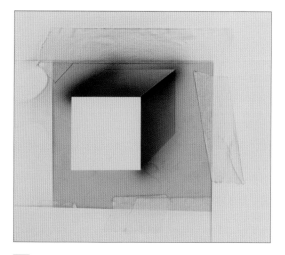

5 Remove the front piece of the cube and spray a very light graduated tone over the exposed area.

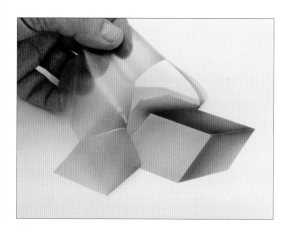

6 Finally, remove the stencil from the surface.

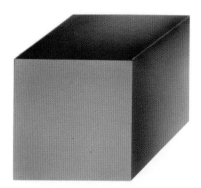

Finished cube

Heart

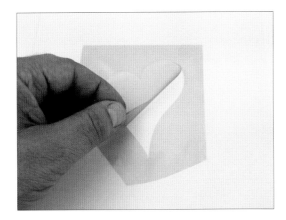

1 Place a small piece of masking tape over the cut-out heart to hold it in position. Remove the paper backing from the stencil and position it on the paper, before removing the cut-out shape.

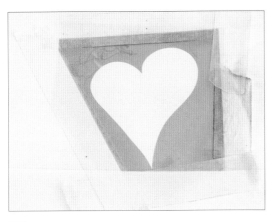

2 Mask around the stencil with paper to protect the surface from overspray.

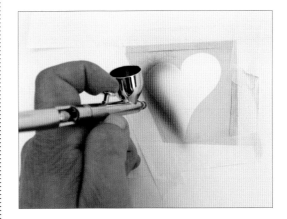

3 Place a few drops of red paint into the airbrush reservoir and begin to spray around the edges of the shape following the curvature in a semicircular movement.

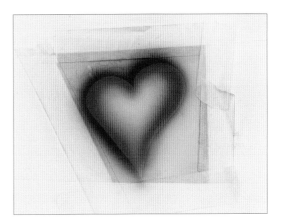

4 Leave the centre area light to create a three-dimensional effect. Make the edges of the heart darkest by spraying over them several times.

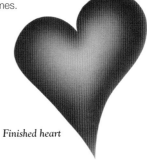

Finished heart

On screen

Find a suitable image to work from. This example uses a stock photograph of the Statue of Liberty, which was purchased and downloaded in digital format from an online picture library.

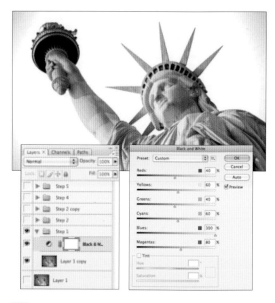

1 Open the image in Photoshop. From the layers palette, create a new adjustment layer for black and white. Move the sliders to vary the contrast in the image.

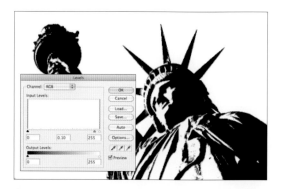

2 Back in the layers palette, create a new adjustment layer for levels. Move the black and white sliders to further increase the contrast in the image. Take care not to move the white slider too far over to the left, as doing so will lead to the loss of too much detail from the original image.

Keep increasing the contrast until you have removed all the grey areas and you are satisfied with the result. You may find it easier to do this gradually, by increasing the contrast slightly, saving the document, then creating another levels-adjustment layer and increasing the contrast further. Repeat this step as many times as necessary.

3 Using the brush tool and pure black, paint in the dark shadow on the arm. Set the brush to 100 per cent on the hardness setting with a 20px diameter for the size.

4 Using pure white with the brush tool, paint out the black areas at the edges of the image and remove any stray black pixels. The resulting image can be printed in black and white onto thin card, then cut out using a stencil burner or scalpel. A Craft Robo plotter will cut your stencil out of thin card or masking film for you, but you'll need to convert the image to a vector using Adobe Illustrator.

This stencil will be used later in the project on decorated clogs, p. 52.

Opaque projector

An opaque projector is used to transfer photographs and drawings onto the surface to be painted and to accurately resize them. While the image is projected you can easily trace the outline with a pencil. This is a very quick and accurate method with which to draw reference sketches. It is also the fastest way to copy images onto canvas or T-shirts, allowing you to render the image very quickly. Projectors are also very useful for working on large murals on interior walls, as you can see the images projected in situ. This will help greatly to make judgements on the correct dimensions and construction of the overall design before you start airbrushing.

TIP

If the image is larger than the viewing area of the projector, scan the image onto the computer and reprint it at the correct size using a desktop printer.

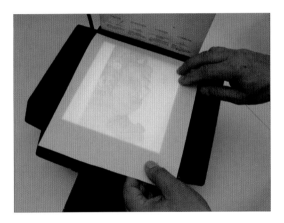

1 Place the image you are working from face down on top of the projector's glass viewing area before closing the lid. Adjust the distance between the projector and the canvas until the projected image is the required size. To correctly focus the projected image, turn the projector's lens. To avoid distorting the image, the canvas should be at right angles to the projector. It is also best to work in a very dark room.

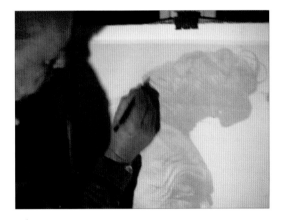

2 When the projected image is in sharp focus, start to trace over the image using a soft pencil until you have drawn the entire image. Be careful not to press heavily on the canvas, as it is important to see the drawing while working on it but not after you have finished the artwork.

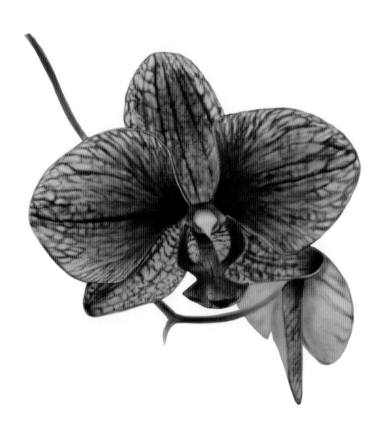

The Projects

With a whole range of different surfaces, techniques and difficulty levels, there's something here for everyone. Absolute beginners will enjoy projects indicated by one or two stars and, with practice and experience, move on to have fun completing those projects with three stars which are suitable for more advanced airbrush artists.

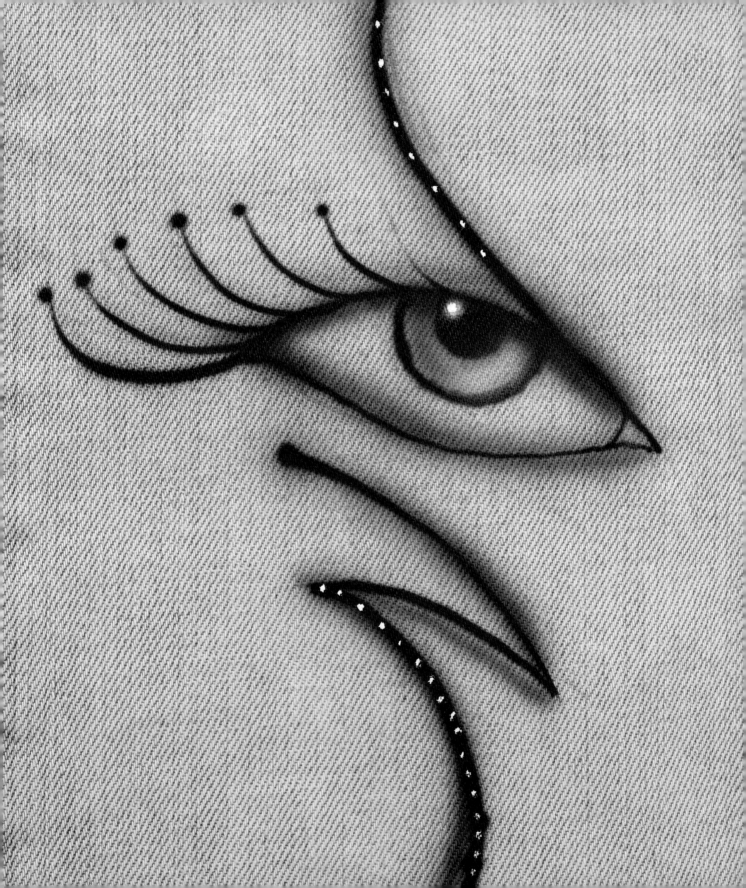

*

Eye
Jeans

Classic jeans can be made into sought-after pieces of fashion with
this simple design. Jazz up an old pair of denim jeans to give them
a new lease of life and make them really stand out from the crowd.

Tools and equipment

- Light-coloured or faded jeans
- Iwata Eclipse airbrush
- Medea textile paint
- Paintbrush
- 5B pencil

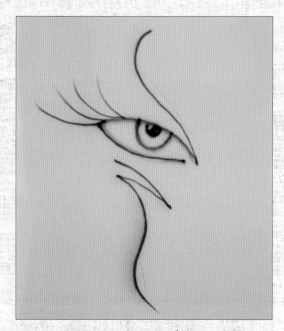

1 Wash and iron the pair of jeans, making sure that they are free from creases. Place them flat on a board, holding them down with tape or clamps, then place the board on an easel.

2 Sketch the outline of the design with a soft black pencil to use as a guide while airbrushing. Repeat the design on the other leg, but facing in the other direction.

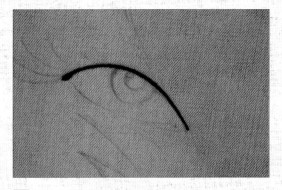

3 Half fill the reservoir of the airbrush with opaque black paint. At a distance of ⅜in (10mm) from the surface of the jeans, slowly spray along the lines of the sketch, starting with the top of the eyelid.

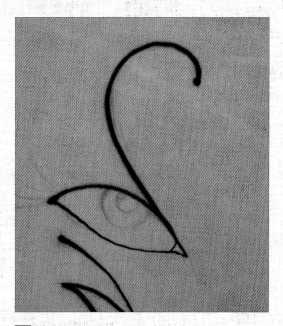

5 In one continuous stroke of paint, spray in the top line above the eye.

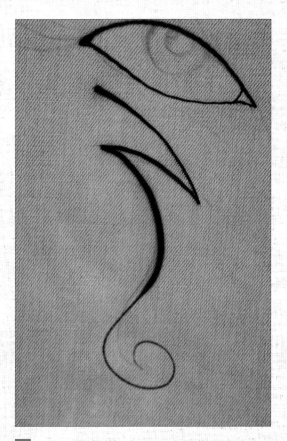

4 Using just one stroke, spray the line at the bottom of the eye. As you continue, vary the distance you spray from to make the lines thicker or thinner.

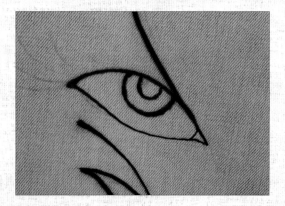

6 Next, spray the outline of the eye.

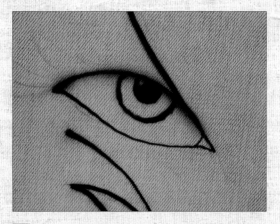

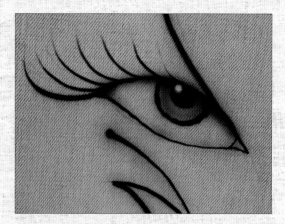

7 Fill in the cornea with black, leaving a small area unsprayed. Then spray a soft shadow under each eyelid.

9 Place a few drops of opaque white paint into the reservoir of a clean airbrush and spray a dot into each eye to create the highlight.

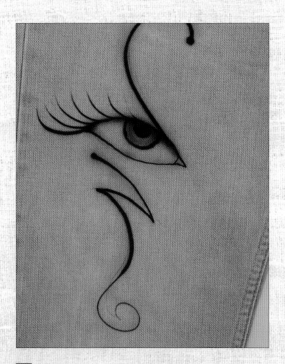

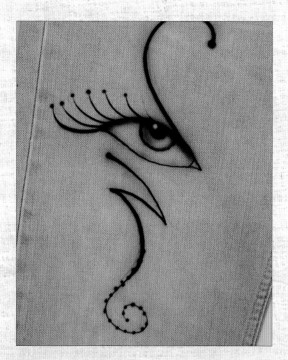

8 Clean the airbrush and flush it through with water. Place a few drops of transparent blue paint into its reservoir and softly spray over the white areas of each eyeball. Next, apply a soft mist over all the lines in the design. Clean the airbrush again, then place a few drops of black paint into the reservoir and spray the eyelashes.

10 Again, clean the airbrush and flush it through. Place a few drops of black into the reservoir and spray dots along the bottom lines and the ends of each eyelash.

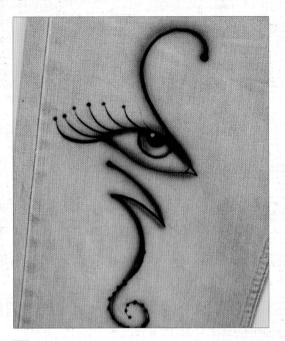

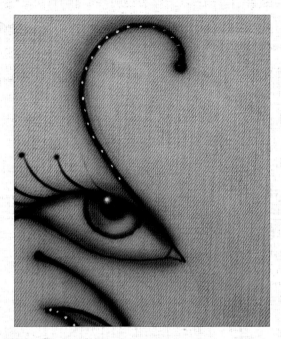

11 Having cleaned the airbrush thoroughly, place some drops of violet paint into its reservoir and use this to spray over all the lines again.

12 With a small lining brush dipped in opaque white paint, place dots on the top and bottom lines. When these dots are completely dry, iron the jeans on the reverse using a cotton setting for several minutes in order to set the paint. Always machine-wash the jeans on a cool cycle.

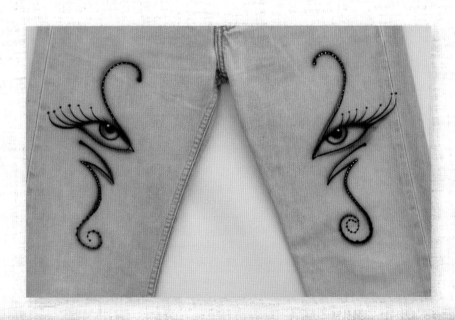

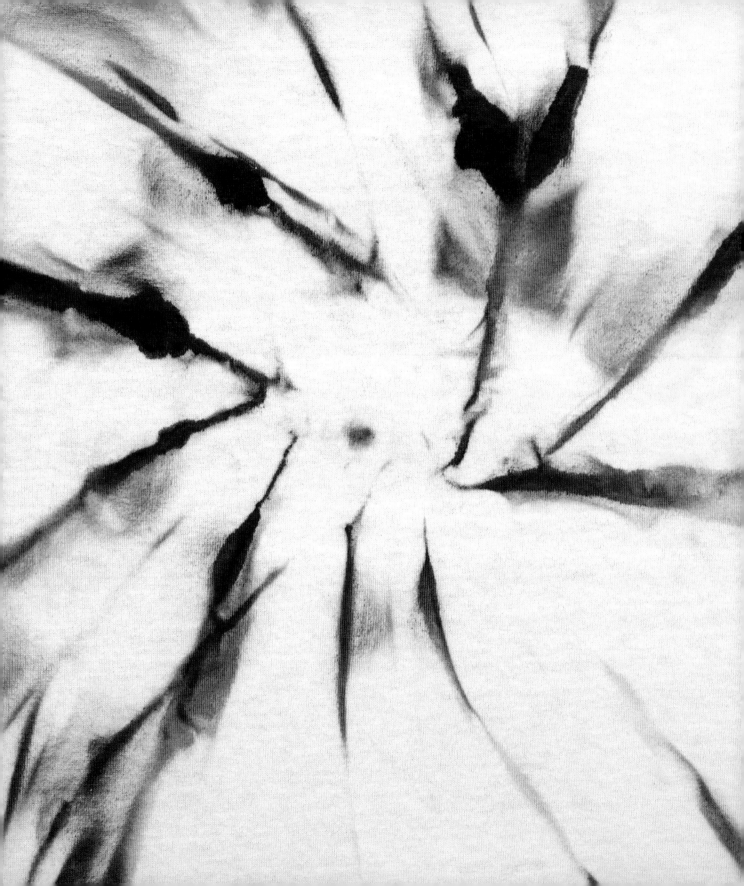

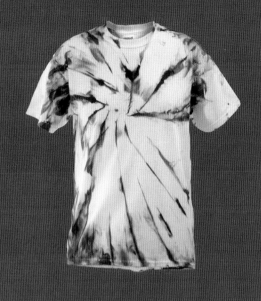

★

Tie-dye
T-shirt

Spraying T-shirts is a very quick way to create a 1960s retro look.
All you need is an airbrush, a few colours and a plain white T-shirt
to create a colourful masterpiece.

Tools and equipment

- Cotton T-shirt
- Iwata Eclipse airbrush
- Medea textile paint
- Wooden spatula
- Elastic bands

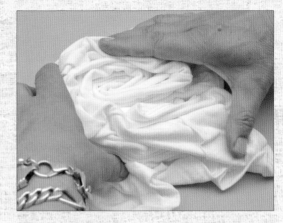

3 Remove the spatula and scrunch up the T-shirt.

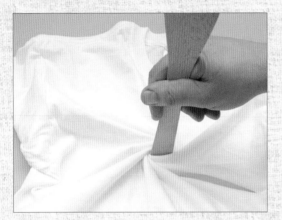

1 Place the T-shirt on a smooth flat surface. Holding the spatula upright, press it down in the centre of the T-shirt. Slowly begin to turn the spatula in a clockwise direction whilst pressing down on the T-shirt.

4 Use several elastic bands to hold the T-shirt together. Then place a few drops of yellow paint into the airbrush reservoir and set the pressure on the compressor to 40psi. Spray into and around the folds from a distance of about ¾in (20mm) away from the surface.

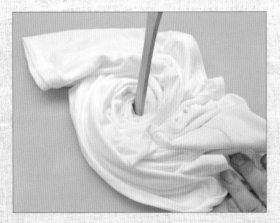

2 As you continue turning, the T-shirt will begin to wrap itself around the spatula. Keep on turning until it is completely wrapped.

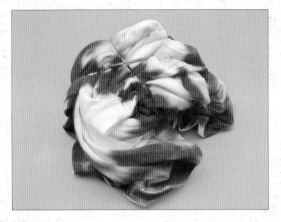

5 Clean the airbrush and flush it through with water. Place a few drops of bright red paint into the airbrush reservoir and spray the folds of the T-shirt.

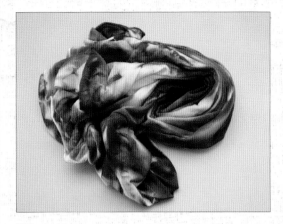

7 Repeat the steps above, but this time place the spatula in a different starting position. Hang the T-shirt up to dry when you have finished spraying.

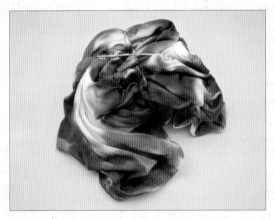

6 Place a few drops of dark blue into the reservoir of a clean airbrush. Again, spray into the folds of the T-shirt, but this time use a more random approach. Carefully remove the elastic bands and open out the T-shirt, then hang it up to dry.

TIP
Red paint sprayed over some of the visible yellow areas will blend together to produce varying shades of orange.

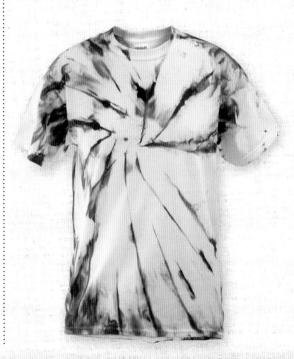

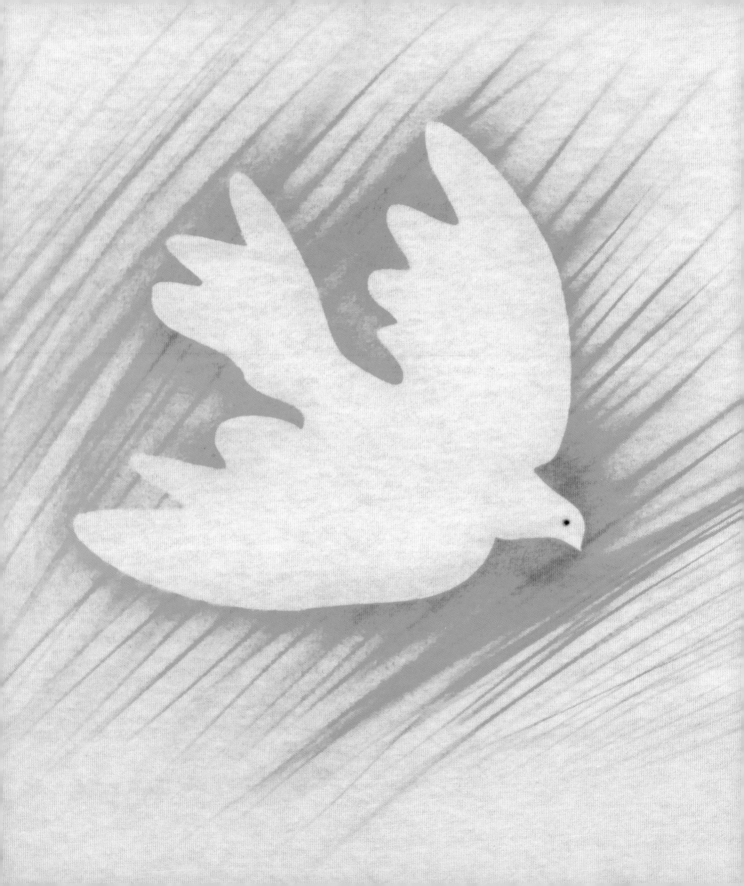

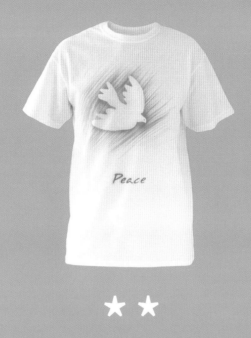

✸ ✸

Peace Dove

T-shirt

Airbrushing onto T-shirts is a great way to practise and learn the basic skills. This is a simple stencil design for airbrushing onto a T-shirt using a universal symbol signifying peace.

Tools and equipment

- Cotton T-shirt
- Iwata Eclipse airbrush
- Medea textile paint
- Craft Robo plotter
- Masking film

TIP
Before you start, ensure that the fabric is free from creases, as these will have an adverse affect on the final artwork.

1 Iron the T-shirt, then pull it over a pre-cut piece of cardboard. Fold the sleeves across the back of the board, keeping them in place with masking tape.

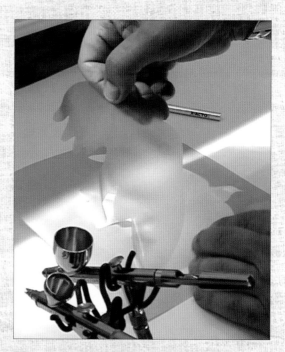

2 Create the stencil using the technique described on page 26. Using the Craft Robo plotter, cut the stencil from masking film. Alternatively the stencil could be created by printing the design onto thin card and cutting it out by hand using a scalpel.

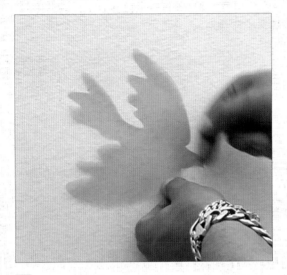

3 Remove the dove shape from the stencil's backing sheet and position it onto the T-shirt.

5 Use long dagger strokes to spray across the stencil at a distance of around 1¼in (30mm) from the surface.

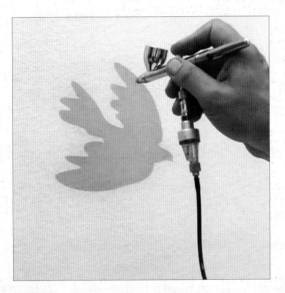

4 Half fill the reservoir with gulf blue paint. From a distance of about 19½in (50cm) away, spray around the stencil to define the shape of the dove.

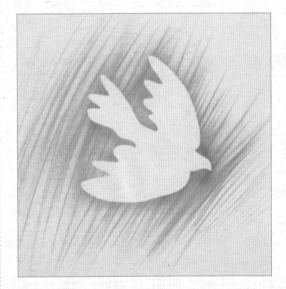

6 Carefully remove the stencil, then clean the airbrush and flush it through with water.

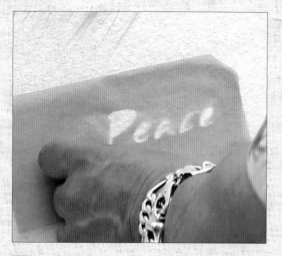

7 Remove the backing from the stencil for the text and position it onto the T-shirt below the painted dove.

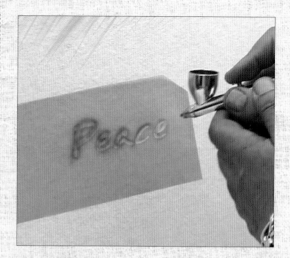

9 Place a few drops of dark blue paint into the reservoir of the airbrush and spray into the letters with a circular motion at a distance of approximately ¾in (20mm) from the surface of the T-shirt.

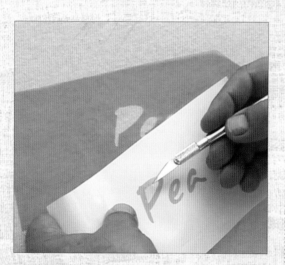

8 Carefully replace the floating stencil pieces for the two letters P and E.

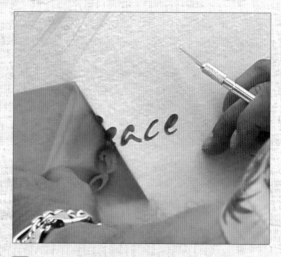

10 Do several passes of airbrushing before removing the stencil with care.

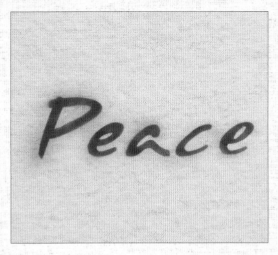

11 From a distance of approximately 1¾in (50mm), spray a light glow around the text.

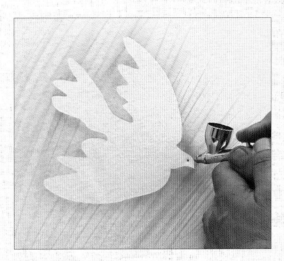

12 Moving closer, to approximately ¼in (10mm), spray a dot for the dove's eye.

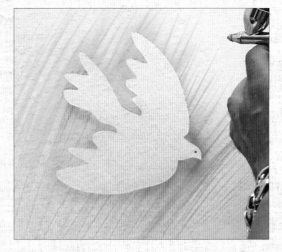

13 Spray lightly around both the inside and outside of the dove from around 1¾in (50mm) from the surface. This will enhance the final image and create a three-dimensional quality.

TIP
Ironing the finished T-shirt on the reverse for around four minutes will set the paint, making it fully machine-washable at low temperatures.

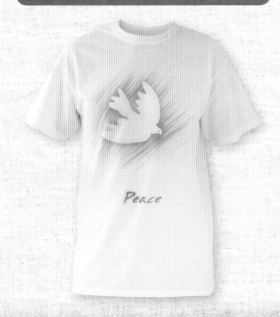

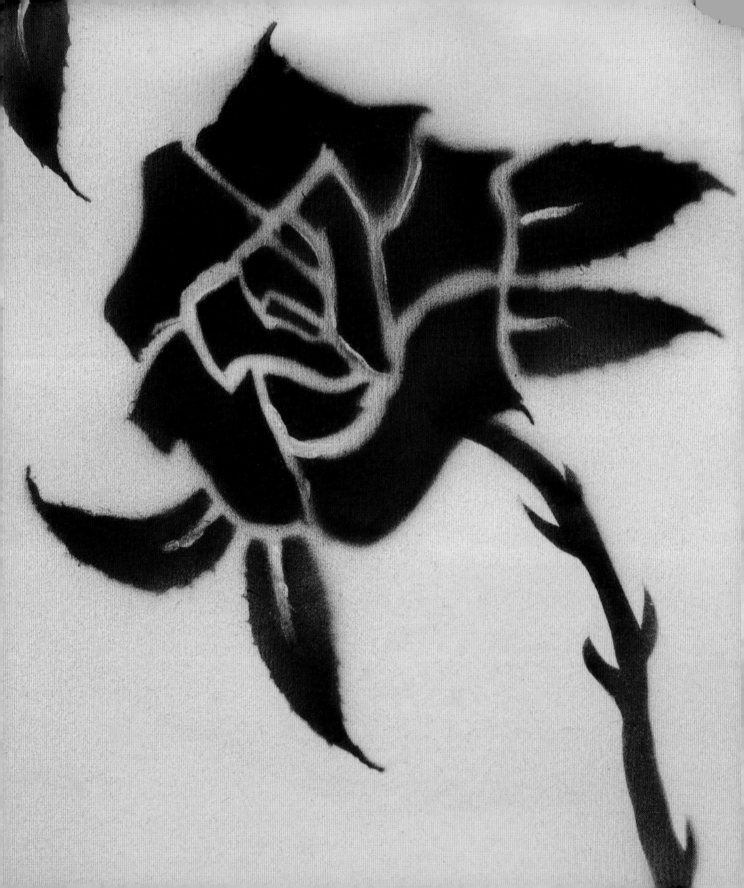

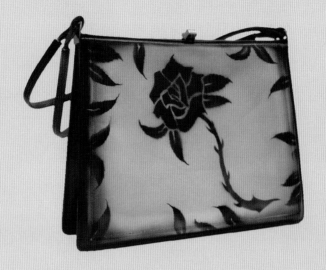

* *

Rose
Handbag

Turn an old neglected handbag into a modern fashion accessory
by using just an airbrush and very simple stencils. By varying the
stencils, you can create a wide variety of designs.

Tools and equipment

- Leather handbag
- JVR K1 airbrush
- JVR Revolution Kolor paint
- Leather cleaner
- Stencil burner
- Masking tape
- Scalpel
- HB pencil
- Plastic sheet

2 Clean the surface of the bag by wiping it down with a soft cloth and a few drops of leather cleaner. It is not necessary to rub the leather. Allow time for the surface to dry completely, then mask around the area to be painted with masking tape to protect the bag from overspray.

1 Draw your design onto a plastic sheet. Remember to leave 'ties' in your design to hold the stencil together and to support the stencil once it has been cut out. Place the plastic sheet over a piece of glass. This is important when using the stencil burner, as it can easily burn through the surface being cut. Tape the plastic sheet down with masking tape and begin cutting out the stencil.

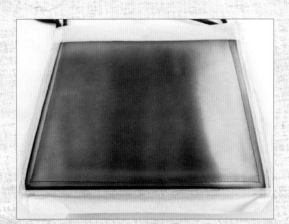

3 Place a few drops of JVR Revolution Kolor white paint in the airbrush reservoir mixed with a few drops of water to thin the paint to approximately the consistency of milk. Set the compressor pressure to 40psi and begin spraying the bag from a distance of about 3in (80mm).

4 Continue spraying and overlapping the white areas until the bag is covered with an even coat of white paint. Leave enough time for the paint to dry completely before moving onto the next step.

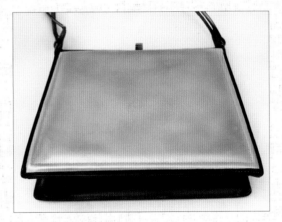

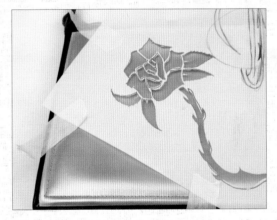

5 Clean the airbrush and flush it through with water. Then place several drops of JVR Revolution Kolor metallic gold paint in its reservoir with drops of water to thin the paint. Mix these together with a paintbrush.

Set the compressor pressure to 50psi so the metallic paint is easier to spray. Begin spraying over the white, overlapping each pass to achieve an even coating of gold. This is easier to achieve by spraying lots of light coats rather than a single heavy coat. Allow the paint to dry completely before continuing.

6 Position the stencil on the bag, holding it in position with masking tape.

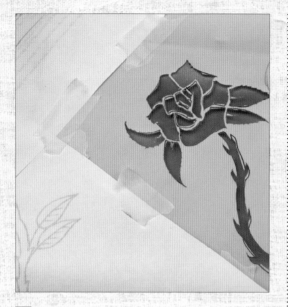

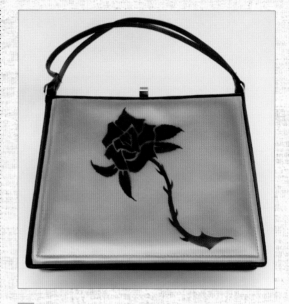

7 Cover the exposed area of the bag with paper to protect it from overspray.

9 Once you have finished, remove the stencil.

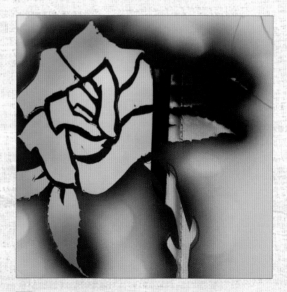

8 Clean the airbrush and flush it through with water. Place a few drops of black paint into its reservoir and change the compressor pressure back to 40psi. Begin spraying over the stencil in a circular motion from a distance of approximately 1½in (40mm). Use your spare hand to press the stencil down to prevent the paint from spraying underneath it.

10 Use masking tape to cover the rose stencil, while leaving the leaves open. Hold the stencil in position on the edge of the bag and spray the leaves in a circular motion from a distance of approximately 1½in (40mm).

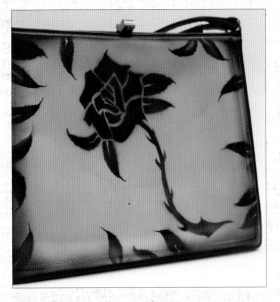

11 Repeat this process until you have alternating leaves all around the edge of the bag.

12 Clean the airbrush thoroughly, then half fill the reservoir with Medea topcoat. Spray several coats onto the bag, allowing at least fifteen minutes between each application. After applying the final topcoat, allow the bag to dry completely before removing the masking tape.

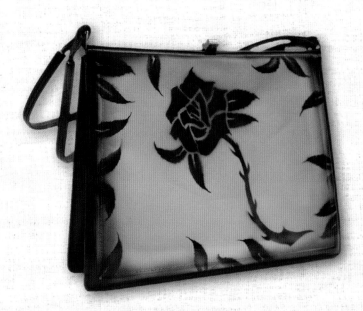

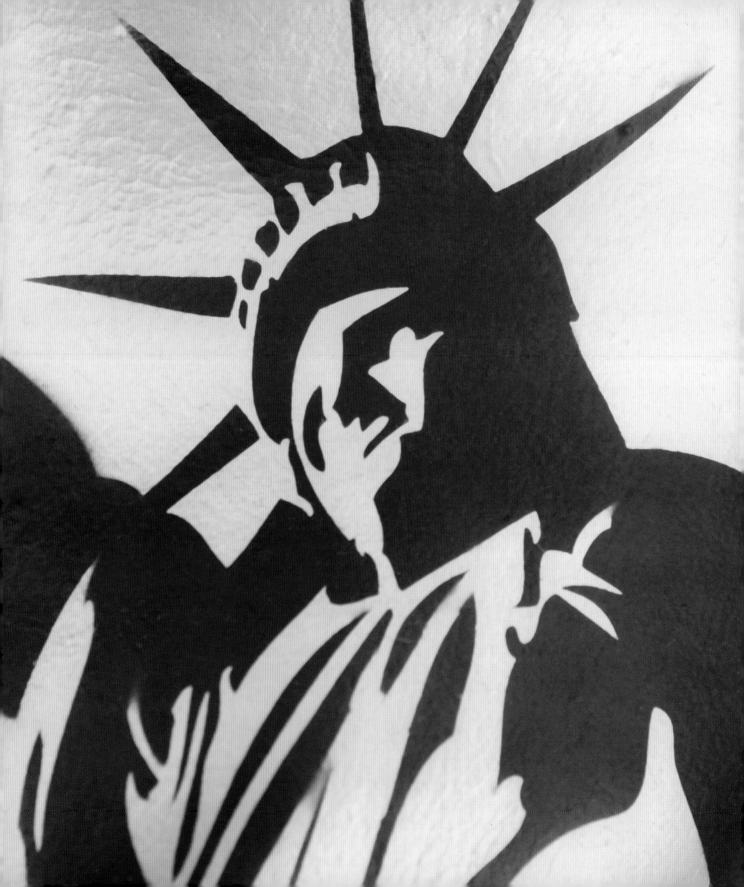

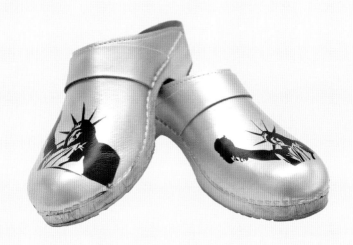

Liberty

Clogs

This is a great way to turn a pair of ordinary shoes into a piece of original eye-catching fashion – with very little effort. Use your imagination to create some cool fashion for your footwear.

Tools and equipment

- Clogs or shoes
- Iwata Eclipse airbrush
- Medea textile paint
- JVR Revolution Kolor metallic gold paint
- Craft Robo plotter
- Masking film

1 Place a few drops of leather cleaner onto a soft cloth. Wipe the surface of the clogs clean, then leave them to dry for at least thirty minutes.

3 Clean the airbrush and flush it through with water. Half fill its reservoir with metallic gold paint and change the pressure on the compressor to 50psi. Again, lightly spray the surface of the clogs from a distance of approximately 2in (50mm) in several coats.

2 To obtain a bright gold colour on the finished clogs, you need to apply a base coat of opaque white. Half fill the reservoir of the airbrush with opaque white paint. Set the compressor air pressure to 40psi, then from a distance of approximately 2in (50mm) from the surface, begin to spray both clogs white. Use a light spray and overlap each pass of the airbrush.

TIP
It is best to build up a good depth of colour by applying several light coats of paint rather than a thick one, which may not dry well causing the paint to run or spoil.

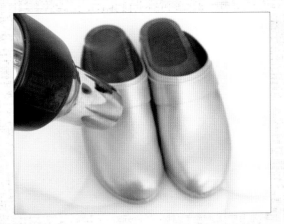

4 Place the clogs aside to dry thoroughly. You can use a hairdryer to speed up the drying time but keep it moving in a circular motion. If it is kept in the same position for any length of time it may well burn the paint.

6 Lightly spray over the stencil several times. Allow to dry before removing the frisket film. Finally, repeat this step on the other clog.

5 Create a stencil using Photoshop. Details on how to do this are outlined in the previous section on page 26. Next, clean the airbrush thoroughly, then place a few drops of opaque black paint into its reservoir. Peel the backing off the masking film before placing the stencil onto the front of the first clog.

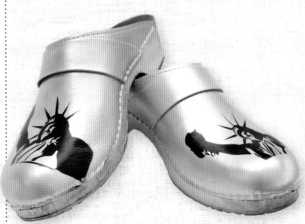

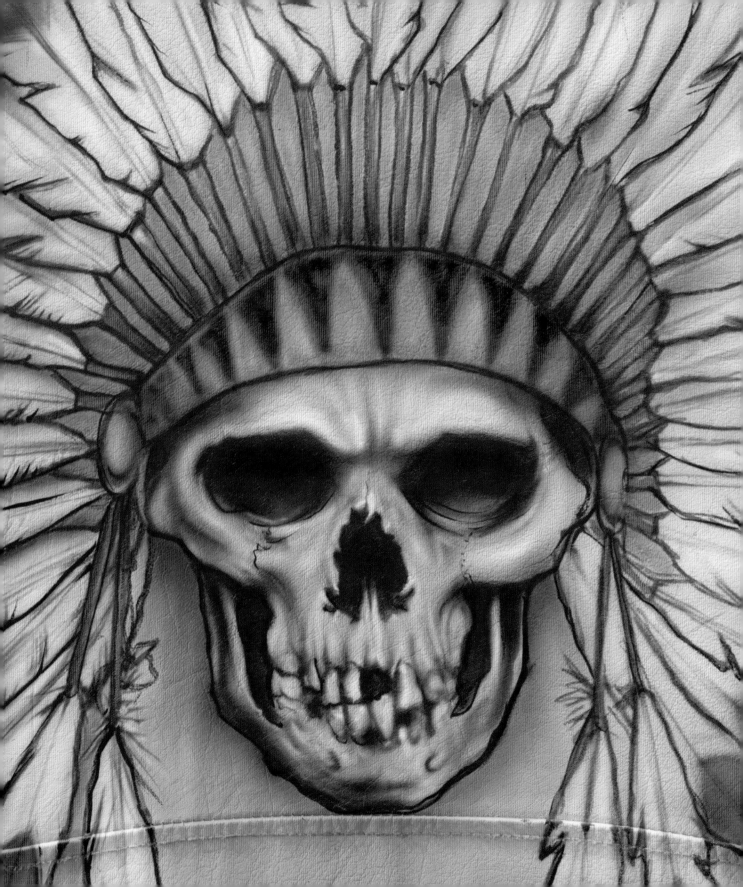

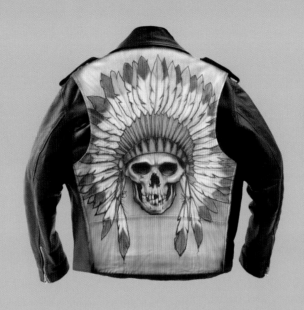

Skull

Leather jacket

The leather biker jacket has become a fashion icon, so why not customize yours and make a statement? This skull-and-headdress design looks great when painted onto black leather.

Tools and equipment

- Leather jacket
- Iwata Eclipse airbrush
- JVR K1 airbrush
- Medea textile paint
- Leather cleaner
- Masking tape
- Ruler
- HB pencil
- Newspaper
- Crocodile clips
- Projector

2 Use masking tape to mask the edge of the areas that are not to be painted, then cover them fully with newspaper. When masking particular areas it is important to ensure that they are well covered and stuck down firmly.

1 Stretch the leather jacket over a piece of cardboard, securing it into place with crocodile clips. With a few drops of leather cleaner on a soft cloth, gently rub over the area to be painted, taking care not to rub too hard. Let the jacket dry out completely.

3 Half fill the Iwata Eclipse airbrush with opaque white paint. Spray this over the back of the jacket at a distance of around 2¾in (70mm) from the surface. Bear in mind that several light coats will create a better result than just a single heavy coat of paint. Continue spraying until the jacket is evenly coated in white.

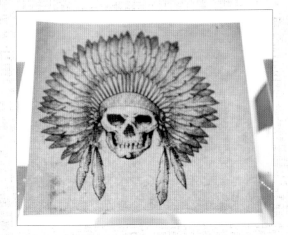

4 Place your chosen photograph onto the glass plate of the projector and close the lid. Turn the lens to focus the image onto the leather jacket. The size of the projected image can be altered by moving the jacket further away from the projector for a larger image and closer to it for a smaller image.

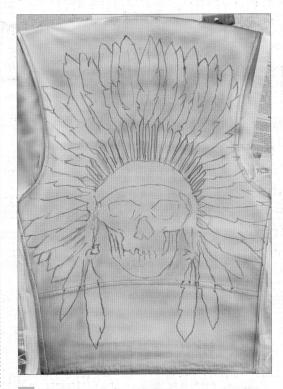

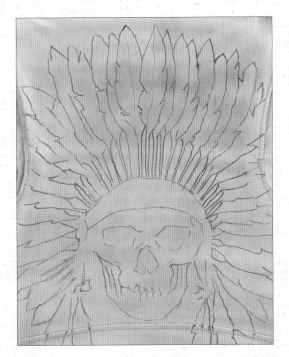

5 Using a soft HB pencil trace around the projected image until you have enough information to start airbrushing.

6 Clean the airbrush and flush it through with water. Half fill its reservoir with opaque blue paint and spray a light mist around the pencil drawing on the jacket from a distance of approximately 2¾in (70mm). Move closer to approximately ⅜in (10mm) when spraying near the edge of the drawing to help eliminate any overspray.

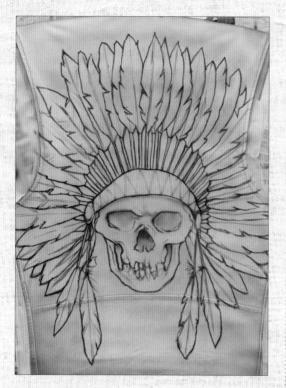

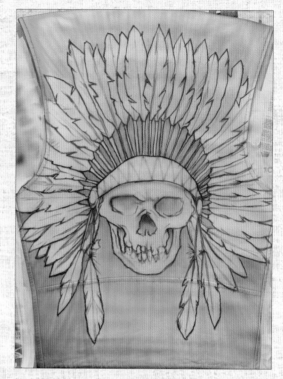

7 Having cleaned the airbrush, half fill its reservoir with cool grey paint along with two drops of opaque black paint mixed together using a small brush. Start spraying at around ⅜in (10mm) from the surface following the sketch lines. The easiest way to do this is to spray the short lines, then go back along the lines whilst moving forward in order to extend them.

8 Clean the airbrush again, then half fill its reservoir with opaque blue paint and go over the blue background. Darkening the background makes the skull and headdress stand out further.

TIP
Practise spraying fine tight lines by following the line several times with the airbrush, yet without spraying any paint. Once you are feeling confident, repeat the movement while pressing on the trigger to release the paint.

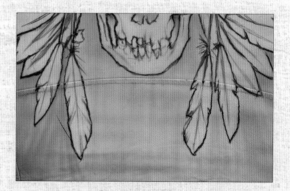

9 Add some texture to the background by spraying some thicker blue lines radiating away from the skull and the feathers.

10 Half fill the reservoir of a clean airbrush with opaque white paint and use this to spray in the feathers. Make them as white as possible by applying several layers of paint. Continue using opaque white to model the features on the skull by spraying the highlights.

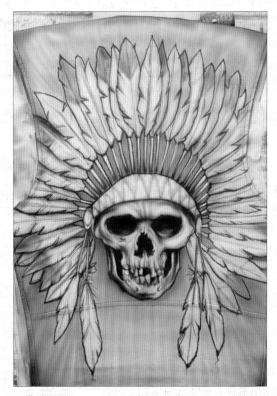

11 Clean the airbrush and flush it through with water. Place a few drops of cool grey paint in its reservoir and spray in the dark areas of the skull (eye sockets, nose cavity, teeth and jaw). Next, add a drop of black to the cool grey and mix it together with a brush. Use this to darken these areas in order to give the skull more depth.

12 Use the same colour to spray some fine lines onto the feathers from a distance of about 1⅜in (10mm) away from the surface of the jacket. Take care to ensure that you spray the lines in the right direction. At the same time, spray over the outline of the feathers and skull to darken them and make them stand out further.

> **TIP**
> When filling in particular areas, spray very close to the edge of the area that you are working on at a distance of approximately ³⁄₁₆in (5mm) from the surface to prevent overspray.

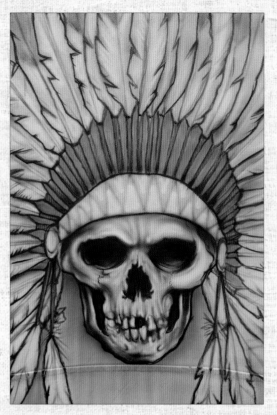

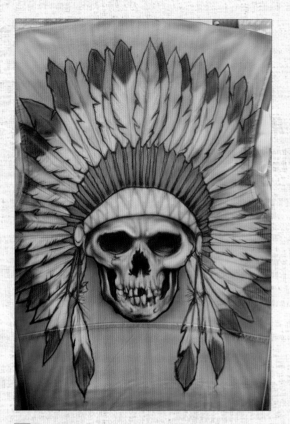

13 Clean the airbrush and flush it through with water. Half fill its reservoir with vibrant red paint and use this to spray the quills at the bottom of the feathers.

14 Continuing with the vibrant red, spray the tips of around half the feathers. When you have cleaned the airbrush and flushed it through again, place a few drops of opaque green paint into its reservoir and spray the remaining feather tips.

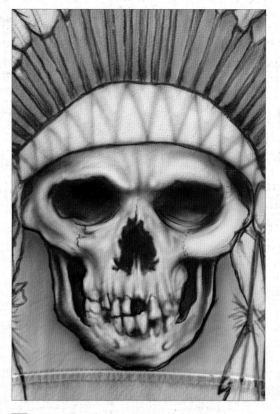

15 Remove the masking tape and the newspaper, then check for any overspray of opaque white on the other areas of the jacket. Place a few drops of opaque black paint into the reservoir of a fully clean airbrush to spray over any areas you find.

16 Continue using the opaque black paint in order to darken areas of the skull.

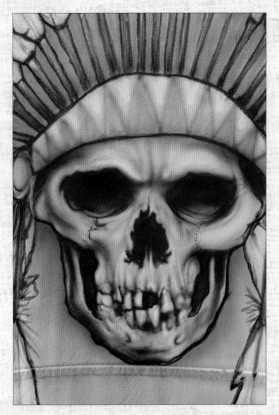

18 Having cleaned the airbrush once again, add a few drops of violet paint into its reservoir. Use this to spray all the downwards-pointing triangle shapes in the headband.

17 Clean the airbrush thoroughly before placing a few drops of golden yellow paint into its reservoir. Spray a light mist over the skull and all the upwards-pointing triangle shapes in the headband.

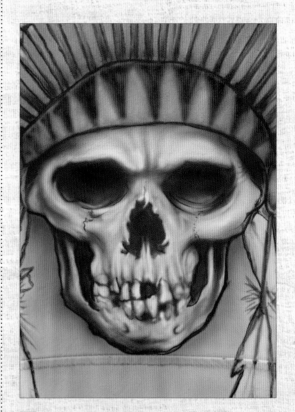

19 Clean the airbrush thoroughly, then place a couple of drops of opaque white paint into its reservoir and spray the highlights back into the skull around the nose and teeth. Leave the jacket to dry for at least 30 minutes.

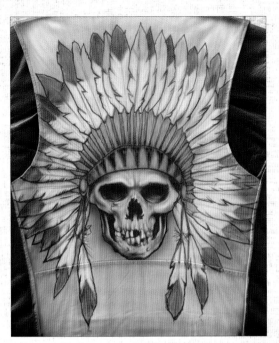

20 Half fill the reservoir of a fully clean airbrush with Medea topcoat. Use this to spray the entire painted area at a distance of around 6in (150mm) from the surface. Start at the top and spray across, moving back and forth until you reach the bottom of the jacket, then leave it to dry for approximately 15 minutes. Repeat this stage until you have applied four or five coats of topcoat. This will protect the painting and allow the jacket to be worn in any type of weather.

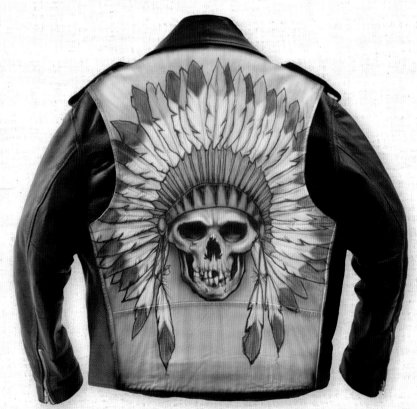

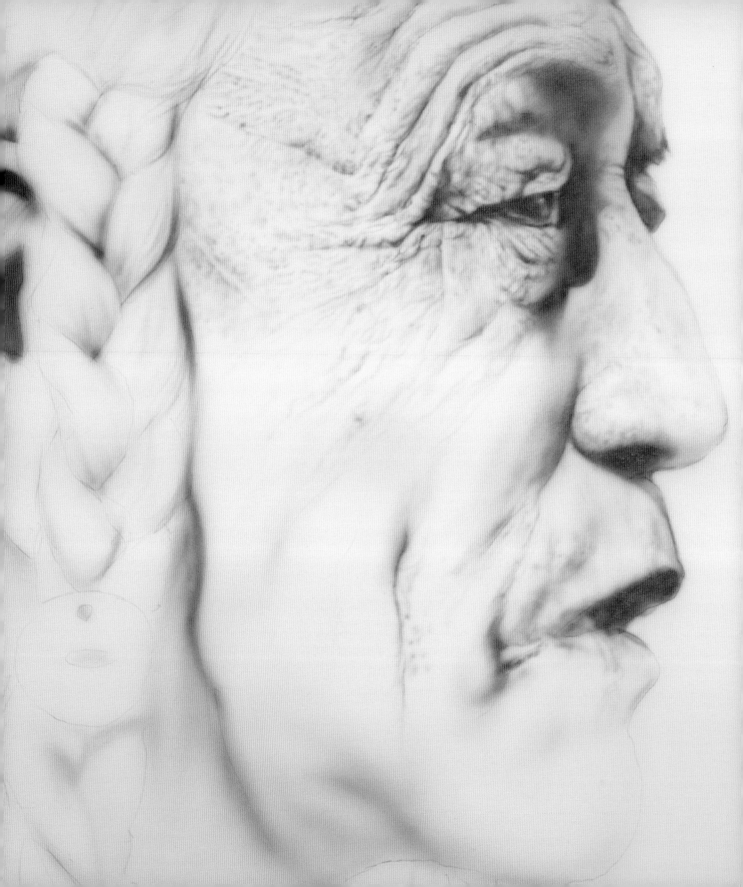

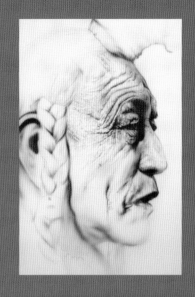

★

Native American
Art paper

This project is a majestic portrait of a Native American. Painting
a portrait such as this with so much detail in the face is a useful
way to learn how to control the airbrush and achieve great results.

Tools and equipment

- Projector
- Cold-pressed art paper (300gsm)
- Iwata Custom Micron airbrush
- Medea textile paints
- Masking tape
- HB pencil

2 Tape the art paper to a mount which can be used to form a border. Place it on an easel and project the picture onto the paper. Enlarge the picture to fit, then sketch the image with an HB pencil until there is enough information to work from, being careful not to press too hard.

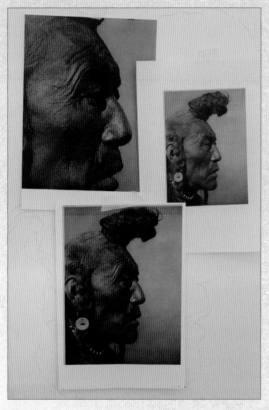

1 Print your reference picture to the same size as the projector's screen. To airbrush the face in detail, enlarge and print a particular section. Study the photograph and take time to become familiar with it.

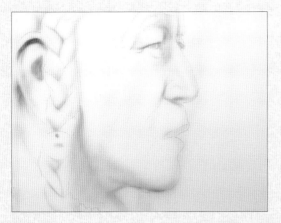

3 With a small brush, mix several drops of Medea transparent light brown paint with a drop of water in the airbrush reservoir. Set the pressure on the compressor to 35–40psi and pull back slightly on the trigger to allow a small amount of paint to pass through. Spray from a distance of approximately ¼in (6mm) from the surface, following the outline of the drawing. There is no need to be too concerned with overspray, as this will become part of the painting. Continue blocking in the facial features, but from a distance of approximately 2in (50mm).

5 Now that the face is beginning to take form, begin to spray in the facial creases and furrows, using an enlarged section of the photograph for reference. Keep spraying very lightly as this makes it easier to build up the creases in the face. The first thing to do when rendering a facial crease is to spray a fine line while working very close to the paper surface, approximately ³⁄₁₆in (5mm) away. Try to vary the line thickness by moving the airbrush in and out from the surface as you work.

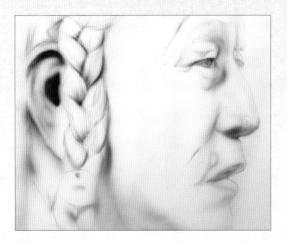

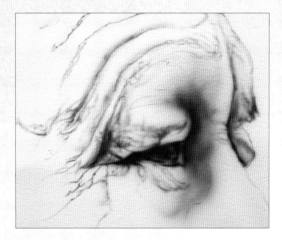

4 Begin to build up the darkest areas in the portrait including the ear, eye, nose, lips, as well as the shading and creases in the face, all the time referring back to your reference image.

6 Study the reference photograph to see which side of the furrow is shaded. Spray along the furrow at around ¼in (6mm) away from the surface of the paper. This will begin to give your painting a more three-dimensional appearance. Use the same technique for the eye socket.

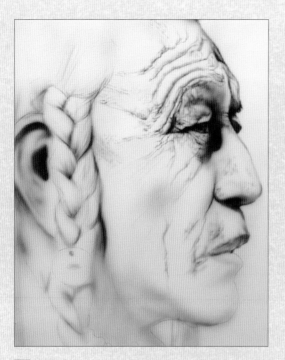

7 Spray the darkest parts of the plaited hair and the fine hairs on the face. Ensure that you are as close to the surface of the paper as you can be when doing this.

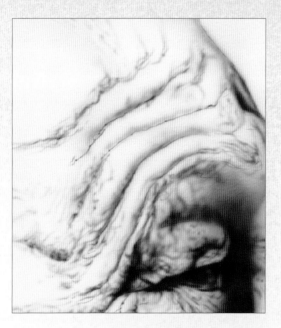

Detail image showing building up of the furrows.

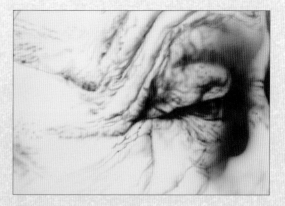

8 Next, concentrate on the eye and the surrounding area. There is a lot of fine detail in this portrait.

9 If you study the reference photograph closely, you will see furrows radiating away from the eye. Build up the cracks and crevices by gently spraying the dark areas and letting the colour of the paper define the lightest parts of the portrait.

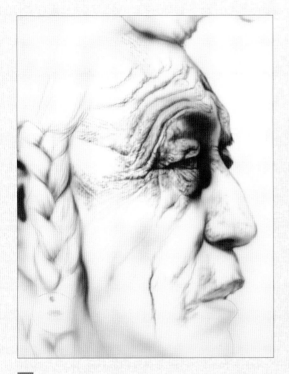

10 Continue close-up spraying and start to work into the lips and the nose.

Detail image showing practice techniques.

11 Build up the very dark parts around the eyes, the lips and the nose. You could continue until the entire piece is worked to this level, but the unfinished look suits this particular portrait even with some of the pencil lines showing through. You will notice that no other colours have been used in this project. The light brown blends with the colour of the paper to produce a warm skin tone.

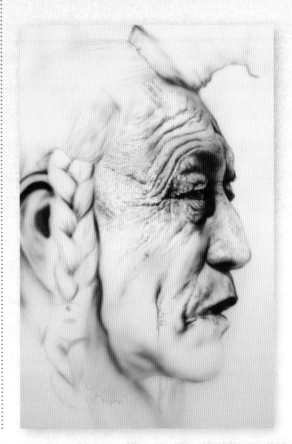

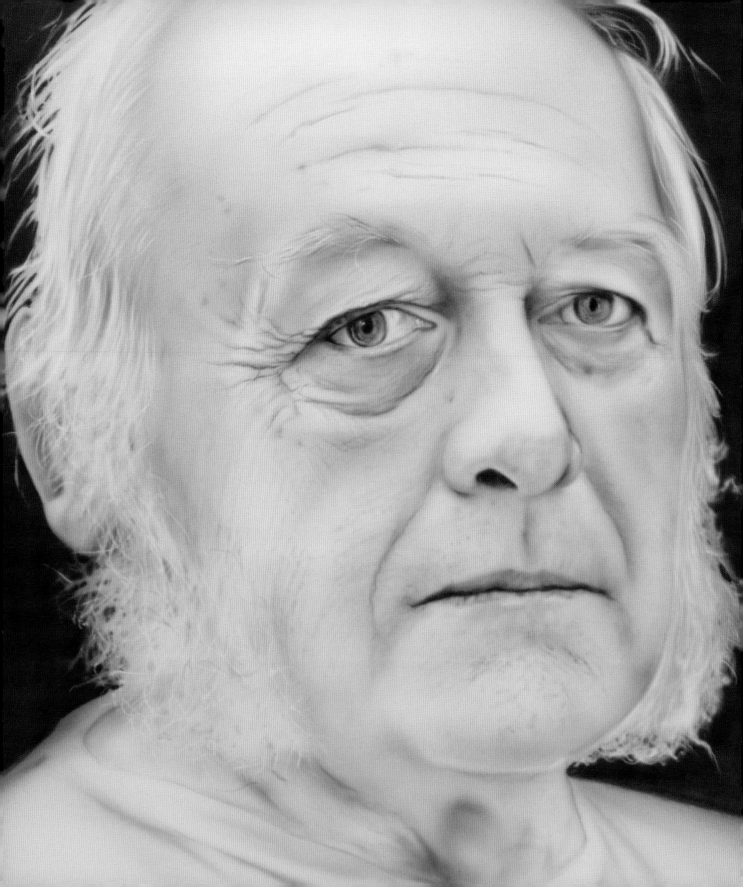

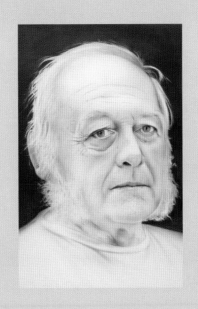

*** ***

Close Friend
Canvas

The aim of a good portrait is to try to capture the essence of a subject's character. John Ogden is a very close friend of mine, one I have known for many years. Here his character shines through. Try creating portraits of your relatives and friends.

Tools and equipment

- Projector
- Smooth surface canvas 30in x 20in (510mm x 760mm)
- Iwata Custom Micron airbrush
- JVR K2 airbrush
- Medea textile paint
- HB pencil

2 Set the air pressure on the compressor of the Iwata Custom Micron airbrush to between 30 and 40psi. Half fill its reservoir with warm grey paint and begin to spray around the face to block in the background. When working close to the edge of the face, spray from a distance of approximately ⅜in (10mm) from the surface of the canvas. When concentrating on areas further away, move the airbrush back to approximately 2¾in (70mm).

Do not worry if the background looks patchy at this stage; it will even out as you apply more layers. Keep building up the layers so the face stands out from the background.

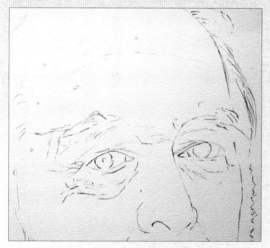

1 Place the photograph face down on the projector viewing area and project it onto the canvas. Use a soft pencil to trace round the outline and details of the face.

3 Clean the airbrush and flush it through with water. Half fill its reservoir with tinting white paint. Begin spraying the fine lines of the hair and the sideburns from a distance of around ⅜in (10mm) from the canvas.

4 Clean the airbrush and flush it through. This time, half fill the airbrush reservoir with warm grey paint and continue with the background.

6 Clean the airbrush thoroughly, then place several drops of opaque white paint into its reservoir. Continue spraying the loose hairs and sideburns into the dark background area from a distance of around ⅜in (10mm).

5 As more layers are applied, the background will become darker. Do not worry if you spray over the white lines as these will show through the grey and will build up the hair, making it look more realistic.

7 Place some transparent gulf blue paint into the reservoir of a clean airbrush, then spray a light mist around the hair and sideburns. Keep checking your reference photograph whilst you work.

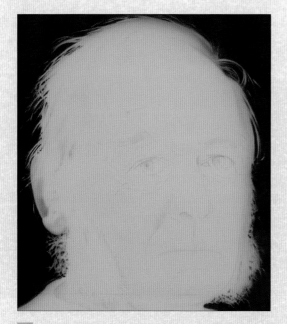

8 Having cleaned the airbrush, place a few drops of warm grey and one drop of opaque black paint into its reservoir. Mix the paint together with a small brush and use it to clean up the overspray in and around the hair and sideburns. Also spray a light, even mist over the face.

10 Still working with the smoky grey, begin to spray into the sideburns. Keep checking your reference photograph to determine the location of the dark shaded areas.

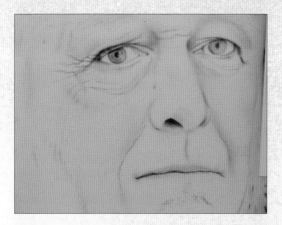

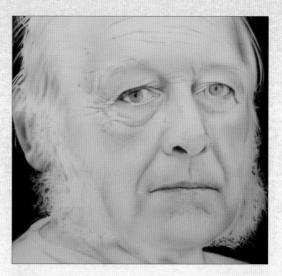

9 Add a couple of drops of smoky grey paint into the reservoir of a clean airbrush. Then commence spraying the main details of the face, eyes, nose and mouth. Spray very lightly from a distance of approximately ³⁄₁₆in (5mm) from the canvas surface when spraying these fine details.

11 Spray a light mist to model the shaded areas of the face to give the portrait a more three-dimensional quality.

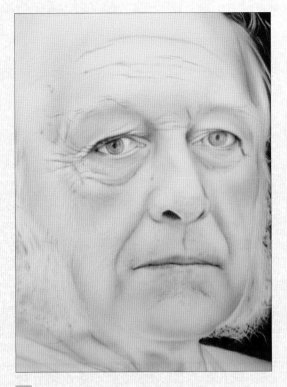

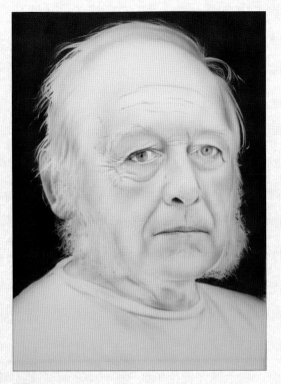

12 Clean the airbrush and flush it through with water. Half fill its reservoir with tinting white paint and spray the light areas of the face, checking your reference photograph at regular intervals.

13 Clean the airbrush thoroughly before adding a few drops of cool grey paint and spraying a light mist over both the sideburns and the hair. This colour has some blue in it and will build a base colour for the sideburns.

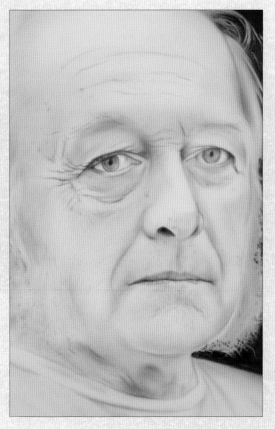

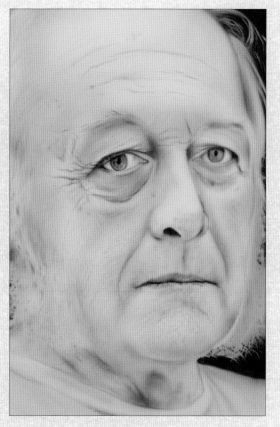

14 With several drops of smoke grey paint in the reservoir of a clean airbrush, add further definition to the facial details, darkening them where necessary.

15 Thoroughly clean the airbrush once again. Place a couple of drops of warm grey paint into its reservoir and darken parts of the face, eyes and lips where appropriate.

16 Clean the airbrush and flush it through. Place a few drops of opaque black paint in the reservoir and use this to spray around the hair and to clean up any white overspray, concentrating in particular on detailed areas such as the eyes and mouth. Clean the airbrush for a final time. Half fill its reservoir with opaque white paint and spray in the highlights of the face. Finish the portrait by spraying the white paint over the sideburns and the hair. In order to achieve a result you are happy with, check the detail in each part of the face. You may have to repeat some of the previous steps.

Close-up detail of the eye.

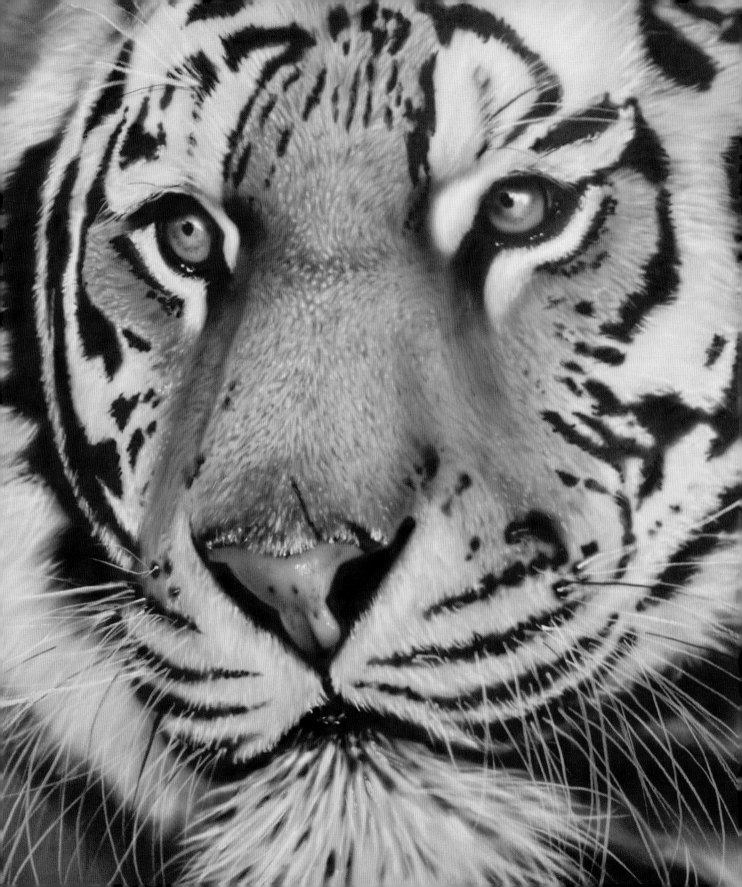

★ ★

Tiger
Art paper

The tiger is a worthwhile subject to paint and helps to highlight the fact that this majestic animal is close to extinction. Studying both light and shade in the reference photograph will help you to create a beautiful portrait with both form and texture.

Tools and equipment

- Projector
- Art paper (300g)
- Iwata Eclipse airbrush
- Medea textile paint
- Masking tape
- Small lining brush
- Soft brown pencil

3 Fill the airbrush reservoir half full with warm grey paint together with a few drops of dark green and one drop of black stirred together with a small brush. From a distance of around 4in (100mm) spray the area surrounding the tiger.

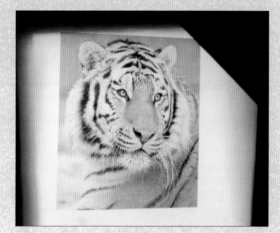

1 Resize the image to fit the window of the projector. Once it is the right size, project the image onto the canvas.

4 Build up the colour by spraying several layers, so the tiger stands out from the background.

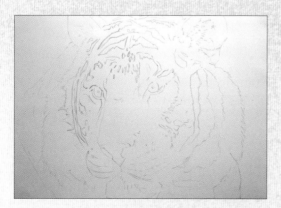

2 Use a soft brown pencil to trace the projected image of the tiger.

5 Clean the airbrush thoroughly and flush it through with water. Half fill the airbrush reservoir with dark brown paint, then from a distance of about ¾in (20mm), spray a line around the markings on the tiger.

7 Place an equal amount of golden yellow and dark brown paint into a mixing jar and stir with a small brush. Having cleaned the airbrush thoroughly and flushed it through, place a few drops of the mixture into its reservoir. From a distance of around ⅜in (10mm) begin to spray small strokes following the angle and direction of the fur. By studying your reference photograph, you will see that the fur radiates in opposite circles, starting from the nose. This step will take a lot of time, but it is worth the effort as it gives the painting a very realistic finish.

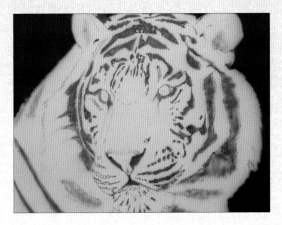

6 Clean the airbrush and flush it through. Half fill its reservoir with dark brown paint and fill in the markings on the fur. This will build up layers in the markings and provide a deep, rich colour. The markings will be darkened later.

8 Continue adding fur strokes, extending them as they radiate out from the nose. Use the same colour to spray a light mist over the fur strokes while being careful not to go into the white areas of the tiger.

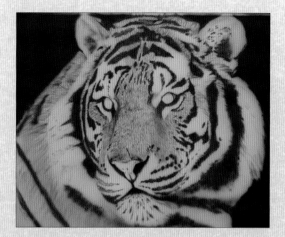

9 Clean the airbrush and flush it through with water. Half fill its reservoir with dark brown paint in order to build up a rich, dark tone to create the markings on the tiger.

11 Having cleaned the airbrush thoroughly, use a few drops of magenta paint in the airbrush reservoir to spray a light mist over the tiger's nose.

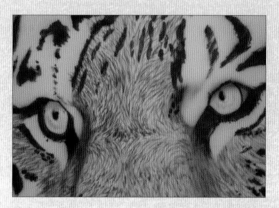

10 Using the same colour, spray in the iris, leaving a small area for the highlight. Spray some very fine lines inside the eye and a shadow across the top of it.

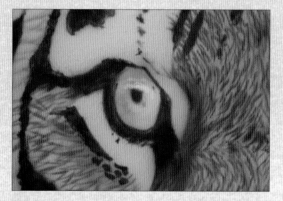

12 Again, clean the airbrush and flush it through. Add a couple of drops of opaque white paint into the airbrush reservoir and add small highlights to the eyes.

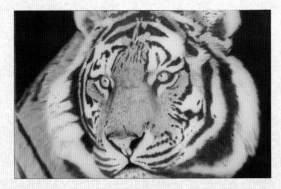

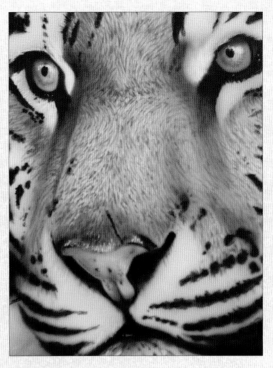

13 Having cleaned the airbrush and flushed it through, place several drops of deep blue paint into its reservoir. From a distance of around 4in (100mm) spray a light mist over the areas of white fur. This foundation will be built upon to create realistic-looking fur.

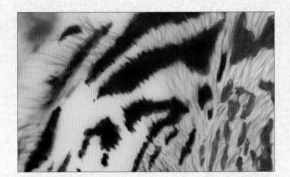

15 Clean and flush the airbrush through, then place a few drops of dark brown paint and two drops of black into its reservoir. Deepen the shadows around the eyes, nose and jaw by adding a few strokes of dark paint to enhance the texture of the fur.

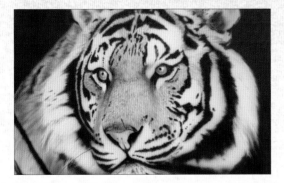

14 Half fill the reservoir of a clean airbrush with dark brown paint, adding four drops of violet and two drops of black mixed together with a small brush. Respray the markings and fill them in, breaking up the markings with short strokes at the edges.

16 Using a clean airbrush, place some opaque white paint into its reservoir and spray small highlights onto the nose of the tiger. Refer back to the reference photograph to double-check their location before you paint them on.

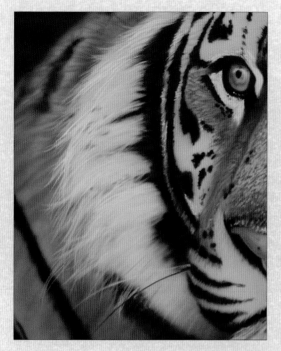

17 Continue using white paint to further develop the fur by spraying strokes over the white areas from a distance of ¾in (20mm). Do not paint in the whiskers at this point, just concentrate on the fur.

19 Clean the airbrush and place a few drops of opaque white paint into the reservoir, then spray more fur strokes over the areas of white fur. Alternate between spraying light mists of blue and opaque white strokes.

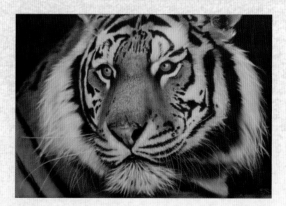

18 Clean the airbrush and flush it through with water. Place several drops of deep blue paint into the reservoir and spray a light mist over the white fur.

20 Again, clean the airbrush and flush it through. Place a few drops of black paint into its reservoir and use this to spray a few whiskers. Clean the airbrush a second time, then place a few drops of white into the reservoir and paint the rest of the whiskers.

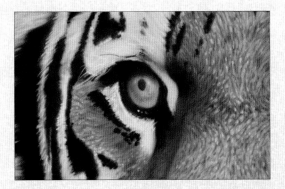

21 Clean the airbrush thoroughly before placing a couple of drops of cool grey paint into its reservoir. Spray in the shadows under the eyes and a few dots into each eye. Clean the airbrush again, add a few drops of yellow paint and spray a fine mist over the eyes.

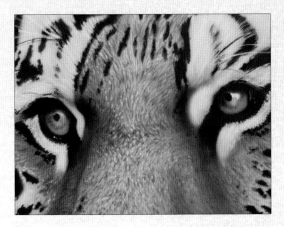

22 Put a few drops of dark blue paint into the reservoir of a clean airbrush and spray over the highlights in the eyes. Clean the airbrush once again, then repeat this step using opaque white paint. Give the airbrush a final clean, then use a few drops of light brown paint to spray around the rim of each eye.

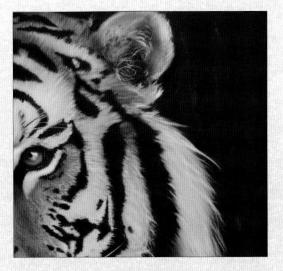

23 Clean the airbrush and flush it through with water. With a small brush mix a couple of drops of cool grey paint and a few drops of black in the reservoir. Use this to clean up any areas of overspray (particularly in the dark background and the fur markings). Clean the airbrush thoroughly for a final time, before placing a few drops of green paint into its reservoir and spraying some thick lines around the tiger in the dark background.

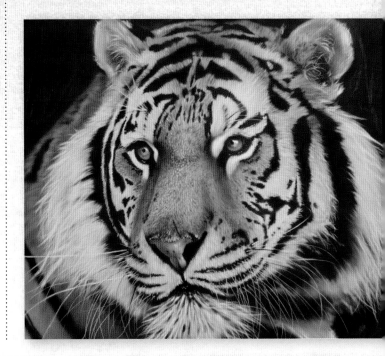

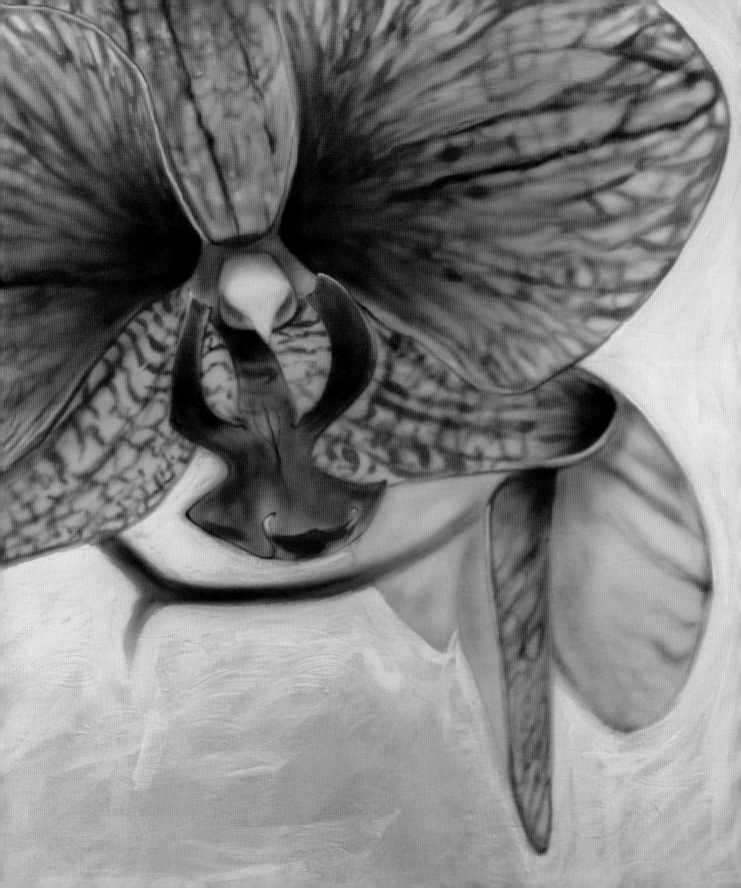

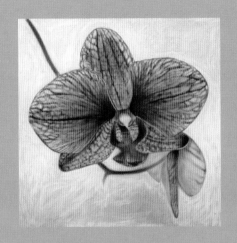

Orchid
Silk canvas

The orchid is an exotic and very beautiful flower with subtle shades of colour and intricate markings. This makes it a great subject to paint onto an equally exotic piece of fine paisley-patterned silk. This design also works well on large canvases.

Tools and equipment

- Large piece of silk
- Iwata Eclipse airbrush
- Medea textile paint
- Tube of acrylic white artist colour
- Canvas stretcher
- Staple gun and staples
- Large paintbrush
- Soft pencil

2 Using a soft pencil, draw the flower from the reference photograph directly onto the silk. Alternatively, project the image onto the silk using a projector.

1 Stretch the piece of silk over the canvas stretcher, keeping it in place with staples at the back applied with a staple gun.

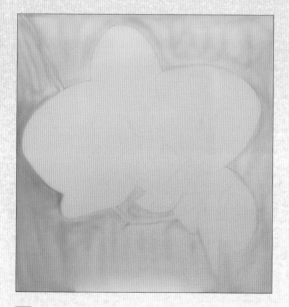

3 Half fill the reservoir of the airbrush with gulf blue paint. Begin to spray around the flower's edge following the outline. Spray close to the line at a distance of ⅜in (10mm) from the surface, taking care not to spray into the petals. As you move away from the flower, start to move the airbrush further away from the surface of the silk to a distance of approximately 2¾in (70mm).

TIP

When spraying onto silk set the compressor to 30–40psi. Do not spray too heavily as this will flood the surface and spread too far.

5 Continue using the magenta to spray the lines on all the petals.

6 Next, outline the centre of the flower.

4 Clean the airbrush and flush it through with water. Add several drops of magenta paint into its reservoir and use this to spray the markings onto the petals. Start by spraying the markings from a distance of approximately ⅜in (10mm). Spray each line in short stages, not in one long stroke. Keep checking your reference photograph to see how the line details are shaped.

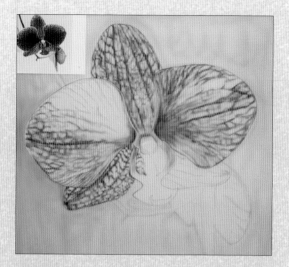

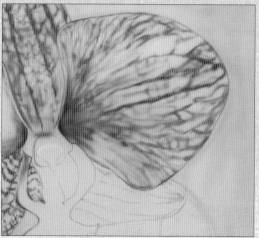

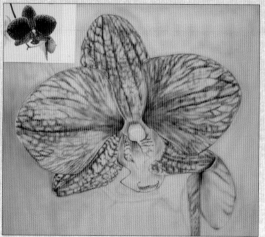

7 Still using the same paint, begin to spray the detailed markings on the petals. This is achieved by moving the airbrush away and back to the surface while spraying in order to vary the thickness of the line.

8 Using the reference photograph as a guide, apply shading to the petals, adding form by spraying from a distance of about 2¾in (70mm) away from the surface.

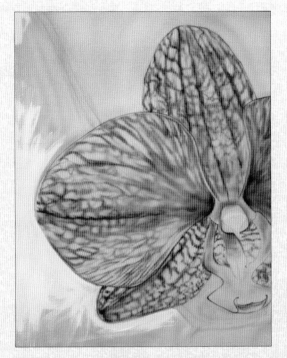

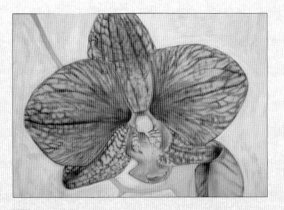

10 Place a few drops of magenta paint into the airbrush reservoir and spray a light mist over the petals. Add several layers over the dark areas for the correct depth of tone.

11 Clean the airbrush and flush it through with water. Place a few drops of violet into its reservoir and spray into the centre of the lines on the petals to make them darker.

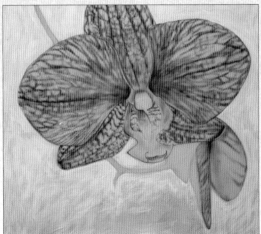

9 Squeeze some white acrylic paint into a pot and stir in a few drops of water, mixing them together with a large paintbrush. Load the brush, then paint around the edges of the flower over the airbrushed blue background. Use thick strokes and do not smooth the paint, in order to give it texture and to make the flower stand out.

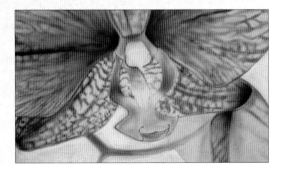

12 Continue using the violet to spray the flower stalks.

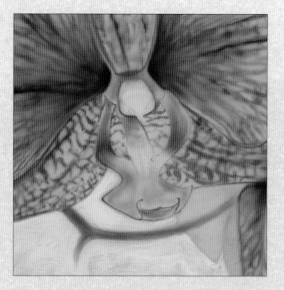

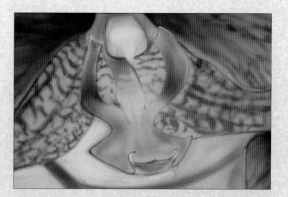

13 Clean the airbrush thoroughly, before adding some drops of golden yellow to its reservoir and spraying the lighter areas in the lower petals. With the same colour, spray over the stems as this will blend with violet and produce a warm brown tone.

14 With drops of opaque white paint in the reservoir of a clean airbrush, spray over the edges of the petals, the centre of the flower and the light areas at the tips.

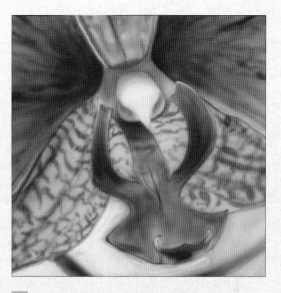

15 Clean the airbrush and flush it through. Place a few drops of magenta paint into its reservoir and use this to darken the centre of the petals by spraying several light layers from a distance of approximately 2in (50mm) from the surface.

16 Finally, with some light brown paint in the reservoir of a clean airbrush, darken the centre of the flower.

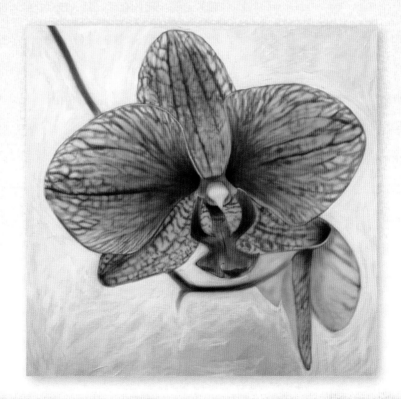

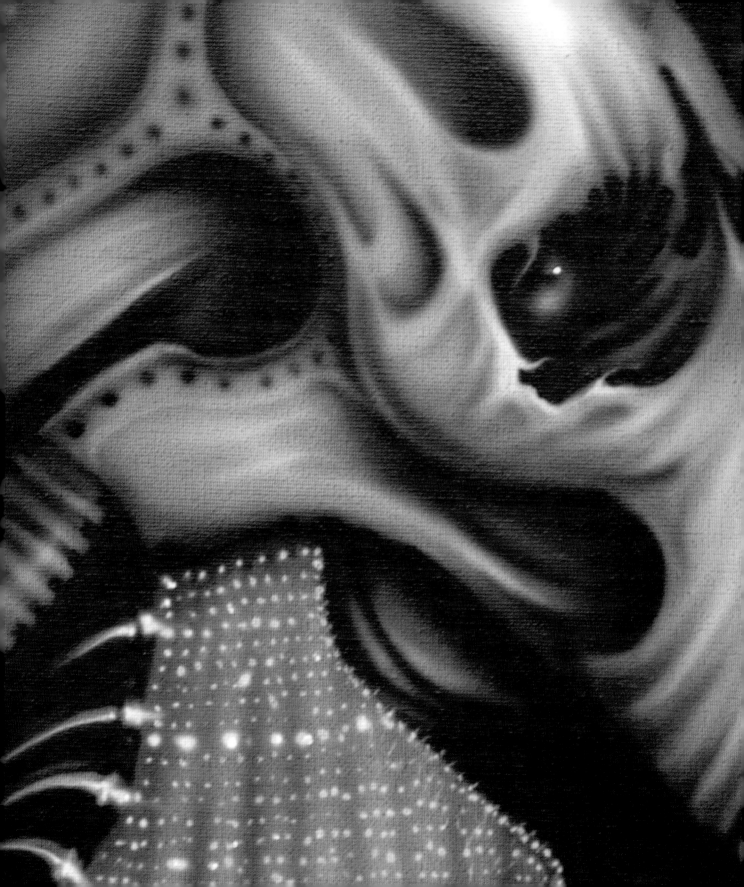

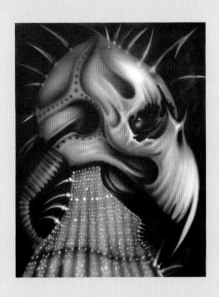

* * *

Science Fiction
Canvas

The inspiration for this project comes from the great fantasy
artist Giger, whose most distinctive imagery is biomechanical
– a mixture of human and mechanical forms. This illustration
is my interpretation of a biomechanical warrior.

Tools and equipment

- Canvas
- Iwata Eclipse airbrush
- Medea colour paints
- Jurek textile colour paints
- Soft pencil

2 Clean the airbrush and flush it through with water. Place a few drops of cool grey paint into its reservoir and use this to darken the surrounding areas of the image. Spray the outlines of the image with the same paint to add definition.

1 Sketch your design in pencil onto the canvas. Half fill the airbrush reservoir with dark brown paint combined with a few drops of black mixed together with a small brush. Spray around the design creating a light mist.

3 Draw a curve on a piece of scrap card or paper and cut along it using scissors. The resulting two halves can be used as a loose mask to achieve sharp edges.

4 With your free hand hold the loose mask against the outline of the design as you spray to ensure you obtain clean edges.

6 Clean the airbrush and place a few drops of dark brown paint into its reservoir. Starting with the darkest areas, begin to model the face. Continue to increase the shading and to sharpen the detail. To achieve sharper lines spray approximately ³⁄₁₆in (5mm) from the surface.

5 Continue to use the grey paint to add layers and darken the surrounding areas.

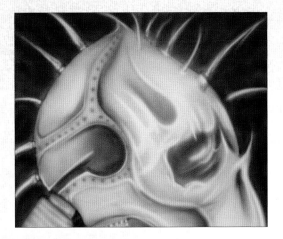

7 Having added several drops of opaque white paint into the reservoir of a clean airbrush, spray the highlighted areas of the head and the spikes around it. Continue using the white to add highlight details to the face.

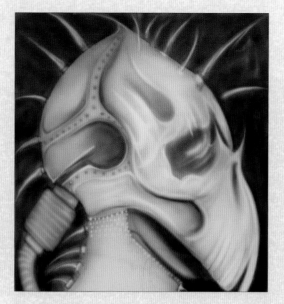

8 Clean the airbrush thoroughly, then add a few drops of blue paint to its reservoir and spray a light mist over the face. Using the loose mask created earlier, spray the blue paint from around ⅜in (10mm) to darken the area around the head and to sharpen the edges of the design.

10 Use the paint to spray very light thick lines from the neck to the body. Then go in close to the surface and spray the details of the tube.

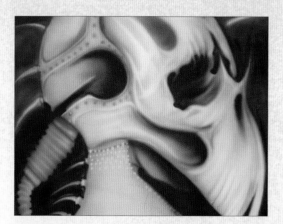

9 Having cleaned the airbrush once more, use a small brush to mix a couple of drops of cool grey, two drops of violet and two drops of black paint in its reservoir. Spraying very close to the surface, as close as ³⁄₁₆in (5mm), in order to achieve sharp lines, spray the paint into the dark areas in and around the eye. At the same time, continue to darken the shaded areas of the face.

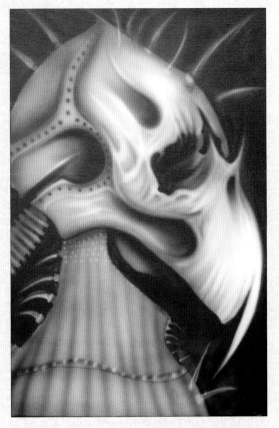

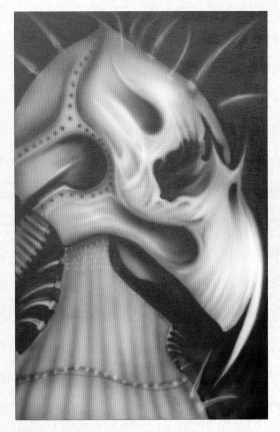

11 Clean the airbrush and flush it through with water. Put a few drops of golden yellow paint into its reservoir and spray a light mist over the entire canvas.

12 Add several drops of pthalo green to the reservoir of a clean airbrush and spray a light mist over the face and upper body.

TIP
With this type of fantasy illustration a lot of the design is created as the work progresses. You can easily alter sections if necessary by going over them in black and repainting the area.

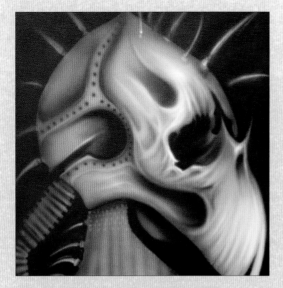

13 Having cleaned the airbrush once again, place a few drops of opaque white paint into its reservoir in order to respray the highlights in the face.

15 Clean the airbrush thoroughly, then place a couple of drops of cool grey into its reservoir. Use this to spray over the dark areas and to sharpen them where there is any overspray. At the same time, sharpen the spikes (top) and model the eye (bottom).

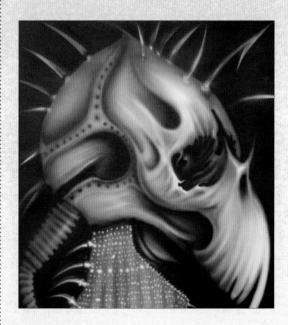

14 Next, spray fine dots into the neck area. To form a small dot, hold the airbrush stationary at a distance of ³⁄₁₆in (5mm) from the surface of the canvas, slowly pull back on the trigger, then let the trigger travel forward. To create larger dots, simply move the airbrush further away from the canvas.

16 Again, clean the airbrush thoroughly before adding a few drops of pthalo green paint into its reservoir and spraying a light mist over the painting.

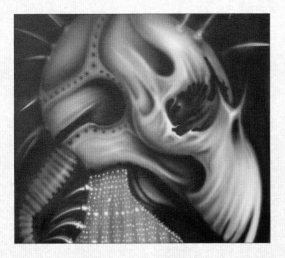

17 Into the reservoir of a clean airbrush, add some drops of violet paint and spray over the dark areas of the face.

19 Dip the point of a fine lining paintbrush into opaque white paint and place a dot for a highlight in the eye as well as placing dots randomly on the neck.

18 Having cleaned the airbrush a final time, place a few drops of golden yellow paint in its reservoir and use this to spray a light mist over the side of the face.

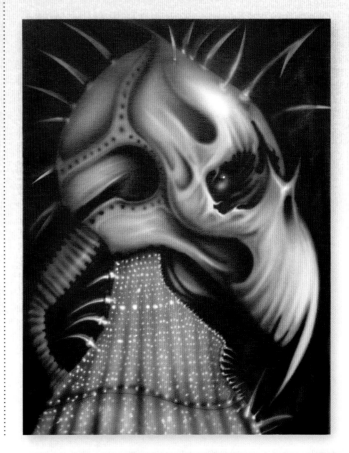

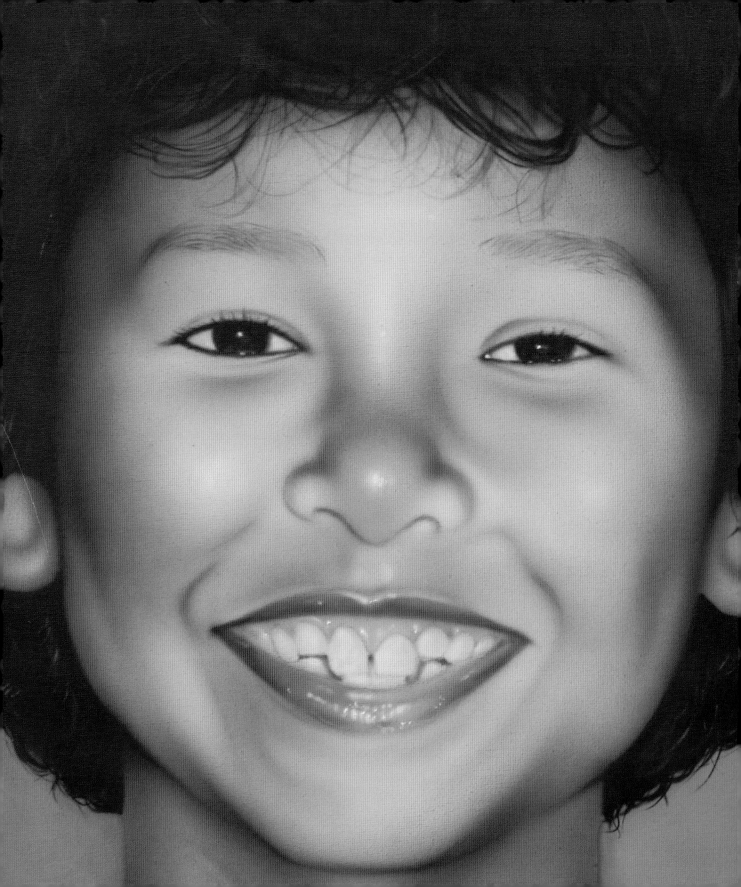

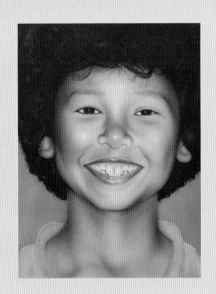

✦ ✦ ✦

Child's Portrait
Canvas

Children make perfect subjects for portraits with faces full of spirit and character. A large colourful portrait makes a striking feature in any modern household and will be treasured by parents.

Equipment

- Iwata Custom Micron airbrush
- Canvas (pre-prepped)
- Medea textile paints
- Medea Com-Art paints
- White acrylic paint
- Fine brush
- Masking tape
- Soft pencil

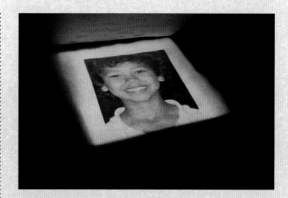

1 Place a strip of masking tape around the edges of the canvas to make a border for the painting.

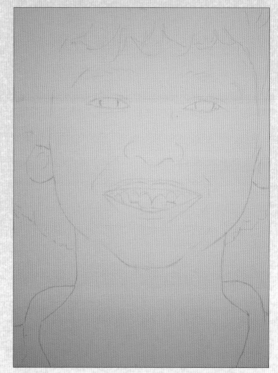

2 Print your reference photograph to fit the projector window. Then project the image onto the surface of the canvas and trace around the face with a soft pencil.

3 Place some drops of light brown paint into the airbrush reservoir and spray a light mist into the hair. It is important to check your reference photograph and to leave light areas in the hair as you spray.

TIP
When spraying a person's hair it is best to follow the shape of their head.

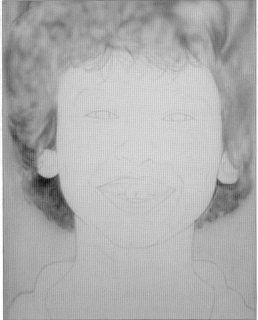

4 Clean the airbrush and flush it through with water. Place dark brown paint into its reservoir and use it to go over the hair to darken it, again leaving the light areas.

5 Continue to build up the dark tones in the hair.

6 Half fill the reservoir of a clean airbrush with dark brown paint. Use a small brush to mix in a few drops of dark blue and spray the paint over the hair.

7 In a small container mix equal amounts of opaque white and cool grey paint. Use a small brush to mix the paint, then use it to spray around the hair and the T-shirt.

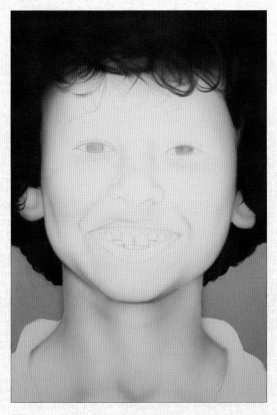

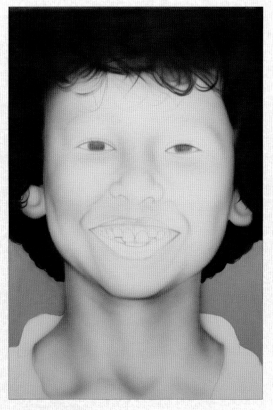

Half fill the airbrush with burnt sienna paint, thinned down with a few drops of water. Mix the paint with a small brush. While referring to your reference photograph, begin to spray a light mist in the dark areas of the face.

Continue spraying very lightly into the shaded areas of the face. Also, darken the eyes as a foundation.

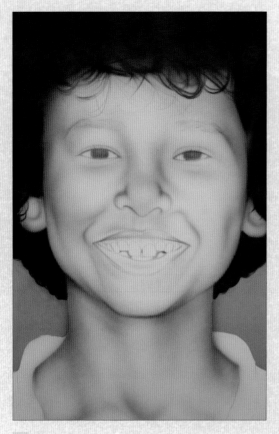

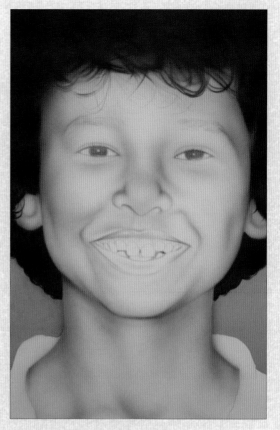

10 Spraying from a distance of ³⁄₁₆in (5mm), spray in the eyebrows.

11 Clean the airbrush thoroughly, then add several drops of tinting white into its reservoir. Use this to spray into the light areas of the face, cheeks, lips and neck. Next, spray dot highlights into the eyes.

12 Clean the airbrush and flush it through. With drops of opaque white in its reservoir, spray fine line highlights into the hair from a distance of approximately ³⁄₁₆in (5mm).

13 Place a few drops of dark brown paint and one drop of black into the reservoir of a clean airbrush and mix them together with a small brush. Leaving some light areas clear, spray into the hair to darken it.

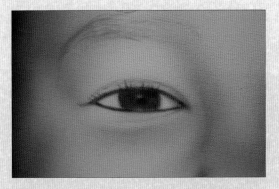

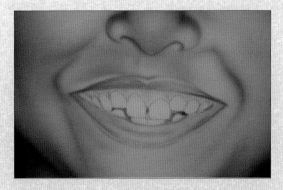

14 Clean the airbrush and flush it through with water. With several drops of dark brown paint in its reservoir, spray the eyelashes from a distance of ³⁄₁₆in (5mm) before darkening the eyes.

16 Place a few drops of magenta into the reservoir of a clean airbrush. While checking the reference photograph, spray a light mist over the lips and gums leaving any light areas clear for highlights.

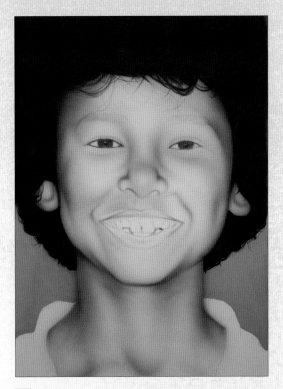

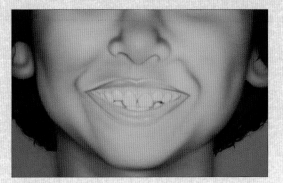

17 Clean the airbrush once again, then with opaque white paint in the reservoir, spray in the highlights on the lips, gums and eyes.

15 Next, spray a light mist into the shaded areas of the face and neck.

18 Having cleaned the airbrush, add some dark brown paint into its reservoir. Spray a light mist over the lips to tone down the magenta.

19 Again, clean the airbrush thoroughly before half filling its reservoir with yellow ochre and spraying in the T-shirt.

20 Spray a very light mist over the face and neck from a distance of 2¾in (70mm).

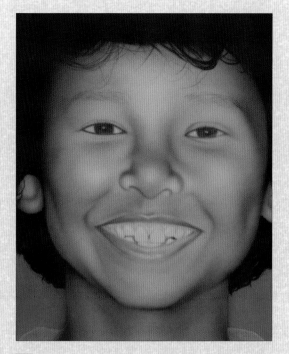

21 Once you have cleaned the airbrush, use a small brush to mix together a few drops of dark blue paint and a few drops of water in its reservoir. Use this to spray a light mist over the shaded areas at the side of the face and the neck.

22 Clean the airbrush and flush it through. With drops of burnt sienna in its reservoir, begin to model the face by spraying very light mists into the light areas. This will begin to develop the cheeks, as well as add shading around the eyes and chin.

23 Leave the area above the nose and forehead light.

24 Having cleaned the airbrush once again, place a few drops of tinting white into its reservoir. Spray the white in the highlights of the face, cheeks, nose, chin and neck.

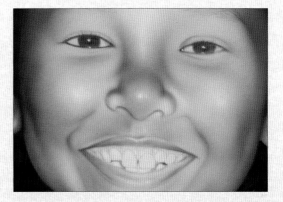

25 In the reservoir of a clean airbrush, add several drops of vermillion paint. Use this to spray a light mist over the cheeks and the top of the nose.

26 Clean the airbrush and flush it through with water. With a small brush, mix together a few drops of dark blue and one drop of black paint in its reservoir. Spray the eyes, then the eye lashes by spraying close to the surface at a distance of ³⁄₁₆in (5mm).

27 Darken the temples and the lines underneath the chin. Still using the same colour, spray some fine lines for the hair over the forehead. While being very careful to follow the shape, spray the eyebrows at a distance of ³⁄₁₆in (5mm) from the surface.

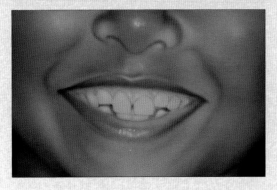

28 Clean the airbrush and flush it through with water. With drops of violet into its reservoir, spray a fine mist over the lips.

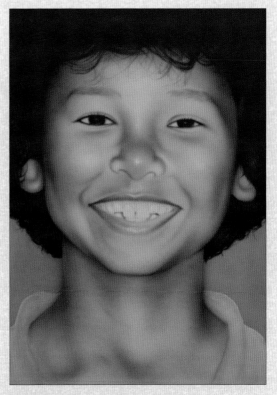

29 Having cleaned the airbrush once more, put drops of golden yellow paint into its reservoir and spray a fine mist over the face and the neck.

30 Put some light brown paint into the reservoir of a clean airbrush and use it to spray a light mist over the lips and the gums.

31 For a final time, clean the airbrush. Place a couple of drops of opaque white into its reservoir in order to spray the highlights in the eyes.

33 Continuing with the same colour, spray fine line highlights in the hair before removing the masking tape from the canvas. Dip a fine line brush into some white acrylic paint and place a dot over the highlights in the eyes.

32 Also spray the highlights on the lips and the chin.

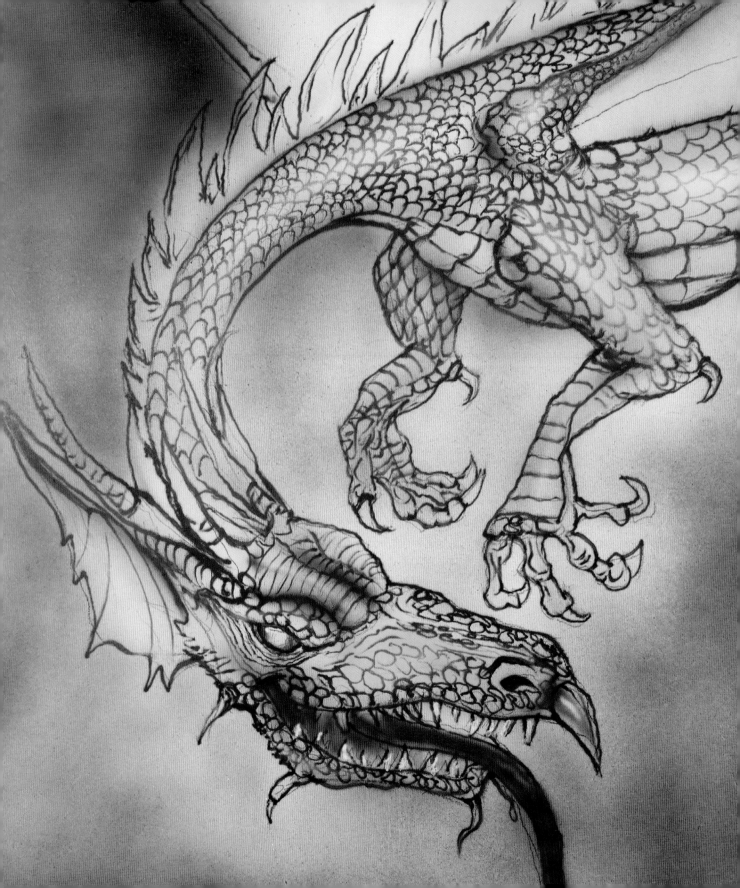

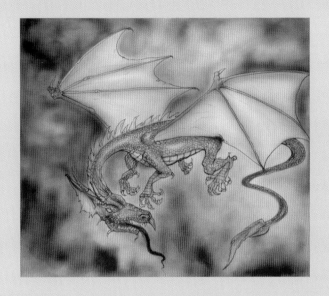

*

Dragon
Aluminium panel

The mythical dragon conjures up a very powerful and dramatic
image and has featured in works of art for over a thousand years.
It can be used on many different surfaces and it is well worth the
time and effort to learn how to paint.

Tools and equipment

- White-coated aluminium panel (D-bond)
- Iwata Custom Micron airbrush
- Iwata Eclipse airbrush
- Medea Com-Art paints
- Createx Wicked Colour paints
- Sandpaper (1,000 grit)
- Tack cloth
- Isopropyl alcohol

1 Sand the surface of the aluminium panel with 1,000-grit sandpaper until it takes on a matt finish. Wipe the surface down with a cloth and isopropyl alcohol in order to remove any grease. Print the reference image to a size that fits the projector window. Trace around the projected image, then draw in all the details.

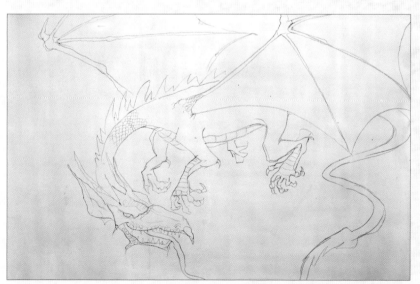

2 Place a few drops of ultramarine blue paint into the reservoir of the Iwata Eclipse airbrush. Spray a light mist over the panel so as to tone down the white, spraying at a distance of about 2¾in (70mm) from the surface of the canvas.

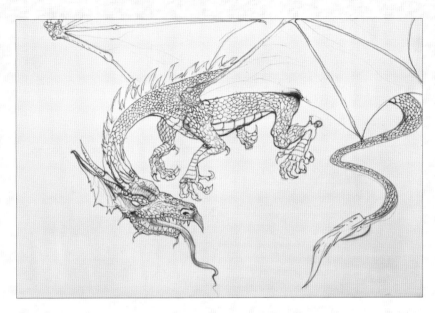

3 Clean the airbrush and flush it through with water. Place a few drops of ultramarine blue paint into its reservoir and spray around the dragon from a distance of around 2¾in (70mm) from the surface. Do not spray an even tone, instead leave gaps in the background, with more light areas left at the bottom of the panel.

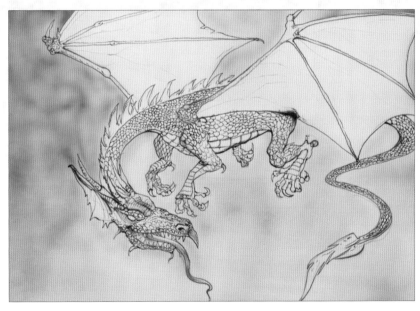

4 Gently, wipe down the panel using a tack cloth to remove any bits of dust or paint particles. Use the cloth periodically while working on this project.

Next, place some drops of transparent black paint into the reservoir of the Iwata Custom Micron airbrush and use this to outline the sketch lines. In order to achieve fine lines, spray very close to the surface from a distance of around ³⁄₁₆in (5mm).

TIP
When spraying long lines, spray them in short lengths, then go back over each line while moving forward.

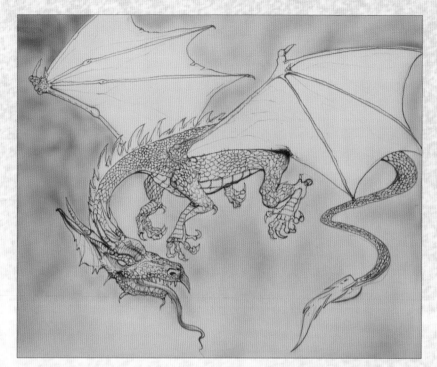

5 Clean the airbrush and flush it through. Place some drops of yellow paint into its reservoir and use this to spray the light areas of the background. At the same time, spray the dragon's eye, inside its ear and its belly.

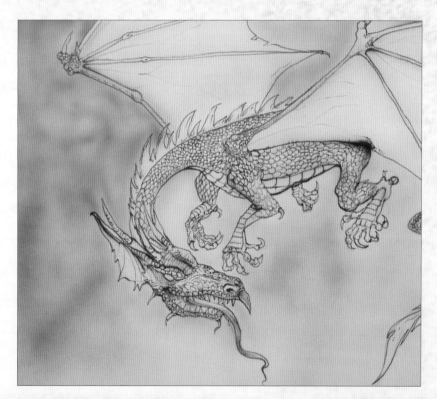

6 Place a few drops of violet paint into the reservoir of a clean airbrush and start to shade the dragon's body and give it form. Continue using the violet to spray the blue background areas.

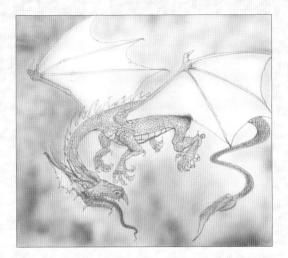

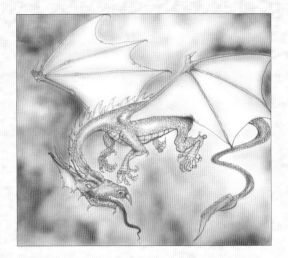

7 Having cleaned the airbrush thoroughly, place a few drops of red into its reservoir and spray around the dragon's eye, its tongue and inside its mouth. Clean the airbrush again and flush it through. Place some drops of green paint into its reservoir and spray the body and wings, applying several coats of paint.

8 Clean the airbrush before placing a few drops of opaque white into its reservoir, using this to spray highlights onto the dragon's skin and wings.

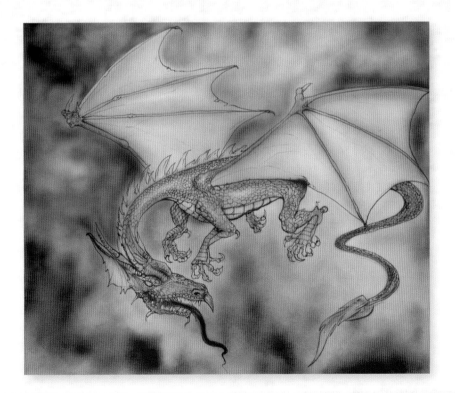

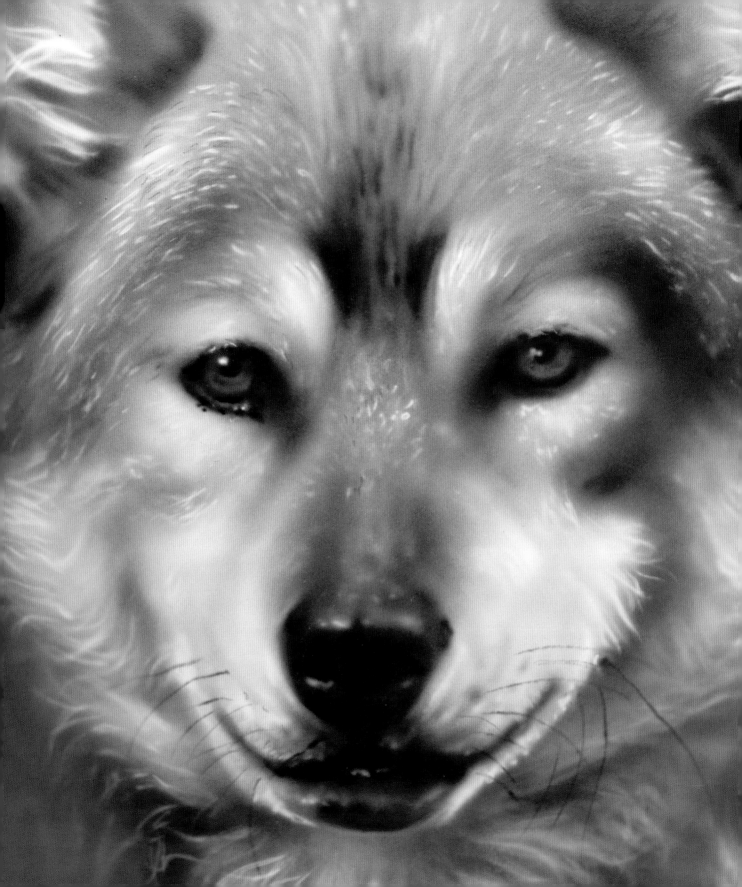

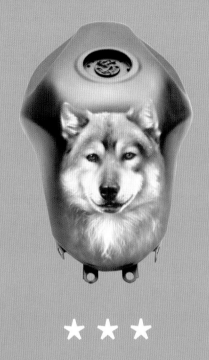

* * *

Wolf
Motorcycle tank

The lone wolf is a symbol of great strength, freedom and power. This image painted on the motorcycle tank captures the essence of a free spirit riding off into the sunset.

Tools and equipment

- Motorcycle petrol tank
- Iwata Eclipse airbrush
- JVR K2 airbrush
- JVR Revolution Kolor paint
- Medea Com-Art paint
- Createx Wicked Colors paint
- Acrylic lacquer
- Masking tape
- Wet-and-dry sandpaper (1,000 grit)
- Cutting mat
- Scalpel
- Alcohol
- Tack cloth

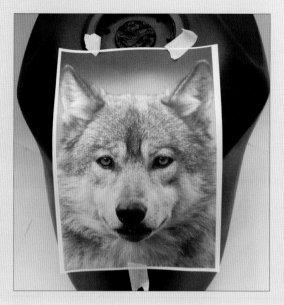

2 Print the photograph of the wolf onto a sheet of A4 paper, then tape it into place on the tank to check positioning and size.

1 Use the wet-and-dry sandpaper (1,000 grit) to gently rub down the tank, being careful not to scratch it. This will remove the clear lacquer coat from the tank's surface and allow the paint to bond with the metal. When the surface has lost its sheen and looks flat, use a clean soft cloth and a few drops of alcohol to wipe the tank clean and remove any grease. Next, spray a light mist of acrylic lacquer over the tank before leaving it to dry for at least 20 minutes. An application of acrylic lacquer to metal will enable paint to bond to the surface.

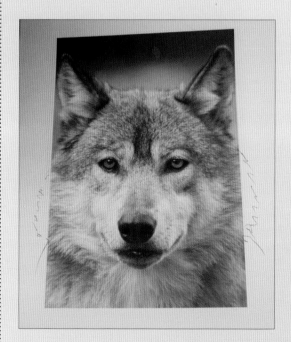

3 Attach the print to a larger piece of paper, then sketch the missing part of the wolf's mane onto the second piece of paper.

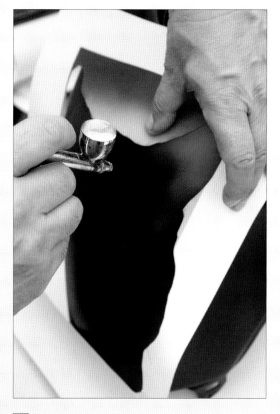

4 Place the image onto a cutting mat and cut around the outside edge of the wolf with a scalpel. Position the cutout on the tank and secure it with masking tape.

TIP
Never use airbrush paints designed for textiles when working on metal.

5 Half fill the airbrush reservoir with JVR Revolution Kolor white paint, adding a few drops of water to thin it out. Set the compressor to 50psi and begin spraying into the mask while using your free hand to hold the stencil in place. This will create a silhouette of the wolf.

Do not worry if there is a small amount of overspray, as this can easily be corrected later on. Due to the curvature of the tank, there will inevitably be some distortion of the wolf, but this will also be corrected as the work progresses.

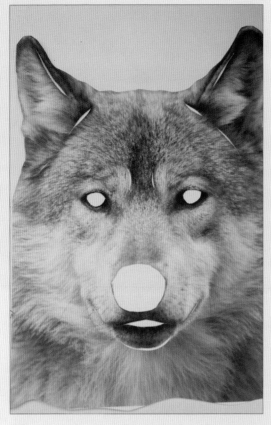

6 Return the main cutout to the cutting mat. Using the scalpel, cut out the eyes, nose and other facial features.

7 Position the mask over the sprayed area and secure it with masking tape. Place several drops of Medea Com-Art transparent black paint into the airbrush reservoir. Spray a light mist into the cutout areas.

8 Clean the airbrush and flush it through with water. Place a few drops of white paint into its reservoir and spray the eyes white. At the same time, build up the fur with long and short strokes following the direction of the fur. By checking your reference photograph you will see that the fur radiates out from the centre of the face.

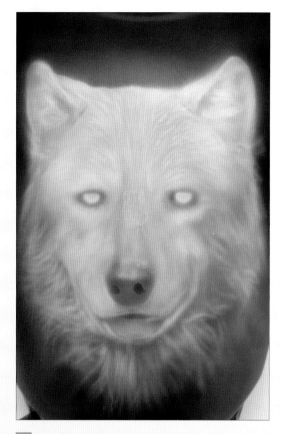

10 Having cleaned the airbrush a third time, half fill its reservoir with white paint. Continue to build up the fur strokes, all the time referring back to your reference photograph. Spray the light areas around the wolf's face, building up the white in layers at a distance of around 1⅝in (40mm) from the surface.

9 Clean the airbrush thoroughly. Add a couple of drops of yellow paint into its reservoir and spray a light mist over the eyes at a distance of ⅜in (10mm) from the surface of the tank.

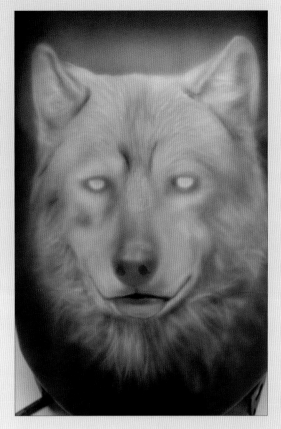

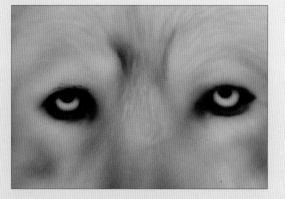

12 Continuing with the transparent black paint, add two black pupils and spray the area around the eyes. Use the paint to build up the depth of colour on both eyes. Spray a light mist shadow over the top of each eyeball.

11 Place a few drops of transparent black paint into a clean airbrush. Look closely at the reference photograph, then begin to model the wolf's facial features by spraying a light mist into the dark areas at a distance of about ⅜in (10mm) from the surface. This will give form to the face as well as depth and dimension to the fur.

13 Still using the transparent black paint, darken and define the wolf's nose.

14 Clean the airbrush and flush it through with water. Add several drops of white paint to its reservoir and use it to spray highlights on the eyes.

15 Still using the white paint, spray highlights on the nose and sharpen the edge of the nose too.

TIP
Throughout the project, occasionally wipe down the painted surface gently with a tack cloth to remove any pieces of dust from the tank's surface.

16 Continue spraying short strokes of white to build up the fur. Use long strokes on the sides of the mane as well as the area under the mouth.

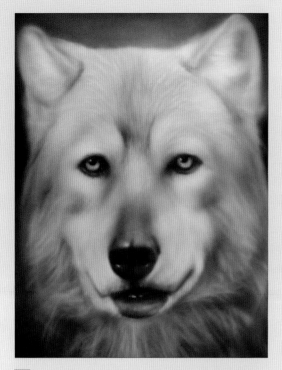

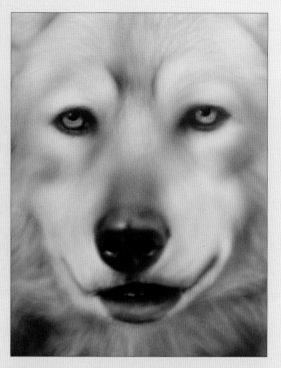

17 Clean the airbrush thoroughly. With a few drops of light brown paint added to its reservoir, spray the areas that are brown in the reference photograph. At the same time, spray a light mist over the yellow in the eyes.

18 Place a few drops of transparent black paint into the reservoir of a clean airbrush, add a drop of blue paint and mix with a small brush. Spray a light mist over the nose, around the eyes and the bottom of the mouth.

19 Next, add fine short fine lines above both eyes.

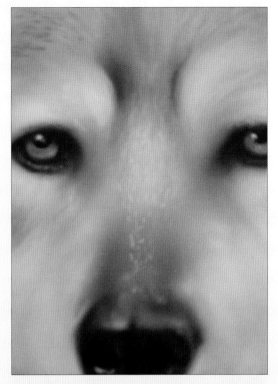

21 Clean the airbrush once again before placing a few drops of dark brown paint into its reservoir and spraying a light mist over the light brown areas to darken them.

20 Having cleaned the airbrush, put a few drops of white paint into its reservoir. Use this paint to spray lines over the fur to make it appear more realistic.

22 Add a couple of drops of white paint into the reservoir of a clean airbrush. Spray lines onto the light areas of the face, the brown areas on the neck and around the nose, using both short and long strokes. Also, enhance the light areas of the fur by spraying a light mist into these areas.

23 Again, clean the airbrush thoroughly. With a small brush mix together a few drops of dark brown paint, two drops of violet and one drop of black in its reservoir. Use it to spray around the outside edge of the wolf as well as the shaded areas of fur on its neck and face before darkening the ears.

24 With a few drops of white in the reservoir of a clean airbrush go over the fur in sections, adding white to make particular areas stand out.

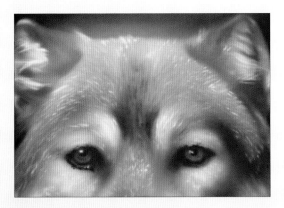

25 Having cleaned the airbrush once again, place some black paint in its reservoir. Spray around the face, shading the image and, at the same time, removing any overspray. Also, spray around the eyes to darken this area.

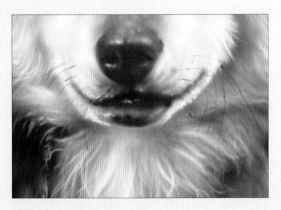

26 Place a few drops of white into the reservoir of a clean airbrush and spray in highlights for the nose and mouth. Clean the airbrush a final time, then with light brown paint in its reservoir spray a light mist over the brown areas to tone down the white strokes.

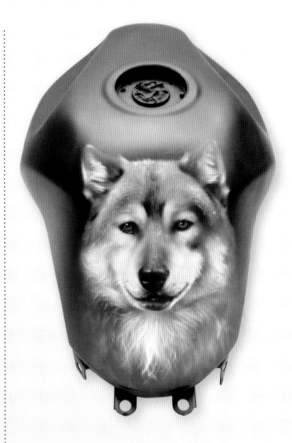

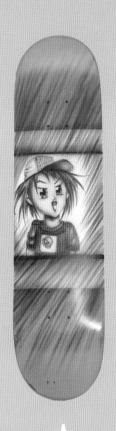

*

Manga
Skateboard

This Manga design is a very contemporary, yet simple image.
Painting it onto an ordinary skateboard will transform it into
a piece of contemporary art, which will make you the envy of
all your friends.

Tools and equipment

- Skateboard
- Iwata Eclipse airbrush
- JVR Revolution Kolor paints
- Medea Com-Art Colours paints
- Createx Wicked Colors paints
- Masking tape
- Cutting board
- Scalpel
- Lining brush
- Acrylic lacquer
- Sanding pad or fine wet-and-dry sanding paper
- Isopropyl alcohol
- Newspaper

TIP
Take your time over the preparation work, as it is vital to ensure that the paint bonds properly to the surface.

1 Clean the skateboard by rubbing a soft cloth dipped in isopropyl alcohol gently over the surface of the board. Soak the sanding pad in water, then squeeze out the excess water. Gently rub the board with the sanding pad until the shine has gone from the surface and it looks flat. Wipe the board and give it time to dry before wiping it again with a soft cloth dipped in isopropyl alcohol.

2 Half fill the reservoir of the airbrush with Medea transparent dark blue paint. Spray an even coat of paint at a distance of approximately 8in (200mm) from the surface of the skateboard. To cover the board it is better to apply several light coats of paint rather than a single heavy coat. When this is finished, you should still be able to see the grain of wood showing through the blue paint.

3 Next, mask the exposed area of the skateboard with paper to protect it from overspray. Half fill the reservoir with opaque white paint and then lightly spray over the exposed area of the board several times from a distance of about 1½in (40mm).

4 When the paint is dry, remove the masking tape.

5 Copy the hand-drawn sketch shown onto the white area of the skateboard using a soft pencil. Alternatively, you could draw your own design.

6 Place a strip of masking tape over the top of the sketch. Leave a gap of about ⅜in (10mm), then place another piece of tape across the board. Repeat this action for the bottom of the sketch, then use paper to protect the top and bottom area from overspray.

7 With a few drops of violet paint in the reservoir of the airbrush, spray along the masked-out line from a distance of around ¾in (20mm) and apply several coats, then allow to dry.

8 Remove the masking tape and the paper from the ends of the board.

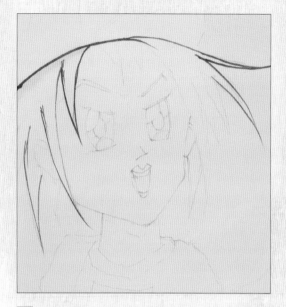

9 Using a fine lining brush with dark brown paint, line in the sketch by following the outlines drawn on the skateboard. Continue with the brushwork until the whole sketch is lined in.

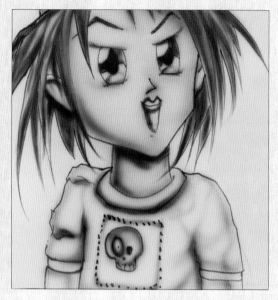

11 Spray the eyes, remembering to leave areas for the highlights. Also shade in the face, hat and shirt, but leave the area around the skull on the shirt white.

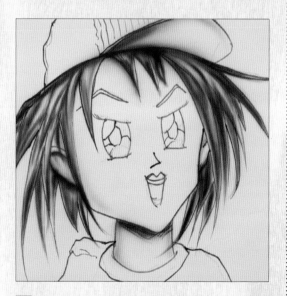

10 Place a few drops of brown paint in the reservoir of the airbrush and begin to shade in the hair and face with a very light spray. Leave some light areas in the hair.

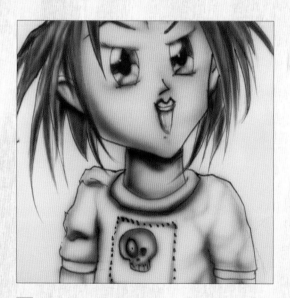

12 Clean the airbrush and flush it through with water. Place a few drops of yellow paint into its reservoir and spray over the light areas that were left in the hair. Spray a very fine mist of colour over the face and inside the little skull on the character's shirt.

13 Having cleaned the airbrush and flushed it through, place a few drops of red paint into its reservoir. Spray the shirt red, going around the outside and inside of the lines to give the body some shape. Continue with the lips, lightly spraying them from a distance of around ³⁄₁₆in (5mm). Try not to get any overspray into the surrounding areas.

14 Again, clean the airbrush thoroughly. With several drops of dark brown in its reservoir, spray lines around the face extending into the blue end section of the board.

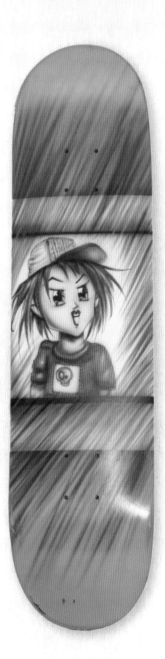

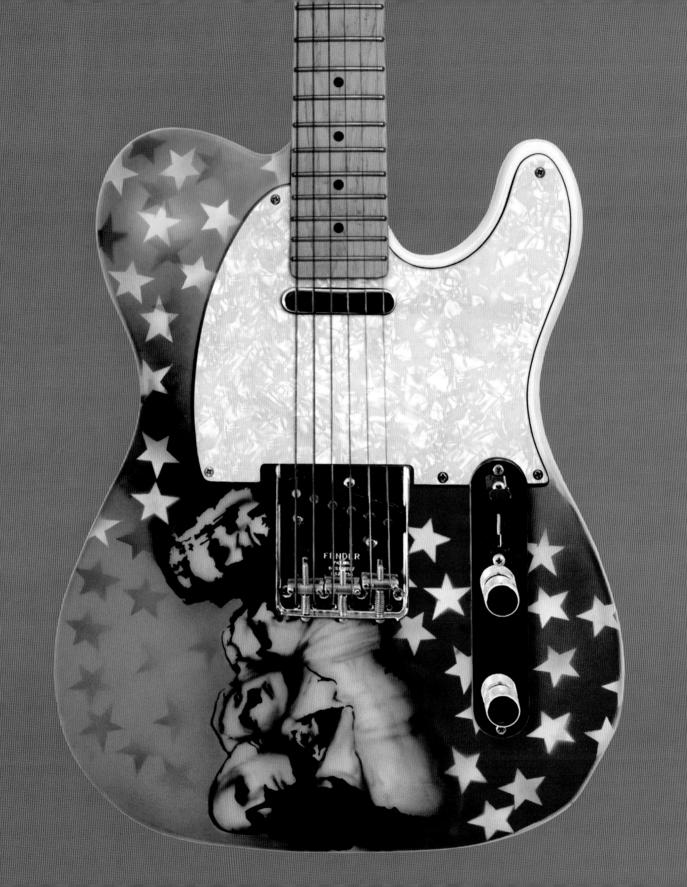

★ ★

Mount Rushmore

Guitar

The iconic electric Telecaster-style guitar is an ideal canvas for a motif of the famous Mount Rushmore sculpture in the US. This project is a quick way to stamp your identity onto your instrument.

Tools and equipment

- Guitar
- Iwata Eclipse airbrush
- Medea Com-Art paint
- Masking tape
- Masking film
- Isopropyl alcohol
- Sandpaper (1,000 grit)
- Acrylic lacquer
- Scalpel
- Soft pencil

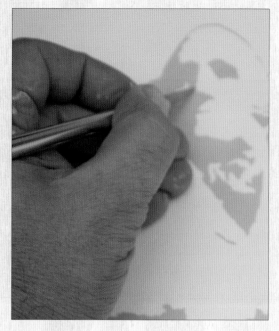

2 Clean off any dust, then wipe the surface down with a soft cloth dipped in isopropyl alcohol. Create the stencil design using Photoshop (see page 26 for full details). Use a Craft Robo plotter to cut out the stencil using masking film. Alternatively print the design in black and white onto thin card stock and cover the surface with masking film. Then use a scalpel to carefully cut out the design.

1 Remove the strings and pickups from the guitar. Rub down the area to be airbrushed with sandpaper until the shine is removed and the surface appears flat.

3 Remove the stencil from its backing and position it onto the guitar. Place masking tape over the edge of the mask to protect the other areas from overspray.

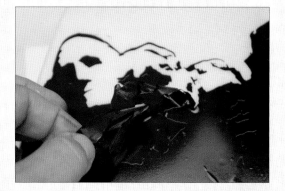

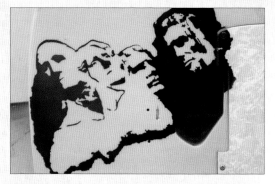

5 Once the paint is dry, remove the masking film. Make sure that you do this very gently as the painted area is very fragile and can be easily scratched.

4 Place a few drops of black paint into the airbrush reservoir and spray over the exposed area of the mask. Use several light layers, spraying from a distance of 2in (50mm). Allow the paint to dry between each layer.

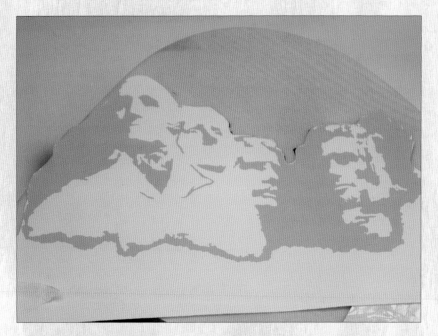

6 Using the backing from the stencil, cut around the image to create a loose mask. Position this mask over the sprayed image and hold it in place with masking tape.

TIP
Use the scalpel to pick off very small pieces of masking film.

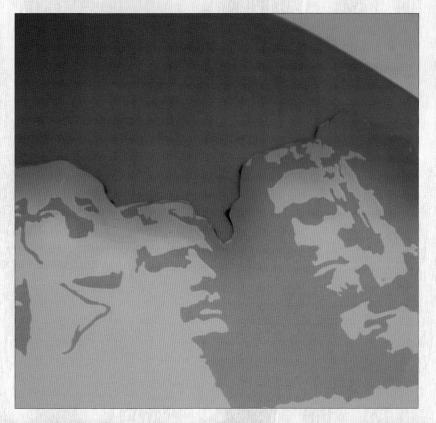

7 Clean the airbrush and flush it through with water. Place several drops of opaque blue paint into its reservoir and spray over the mask and the top of the guitar body.

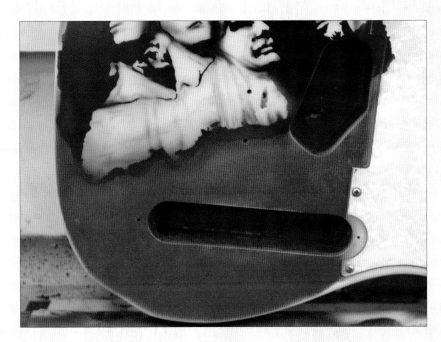

8 Clean the airbrush thoroughly. With opaque red paint in its reservoir, spray the bottom area of the guitar body.

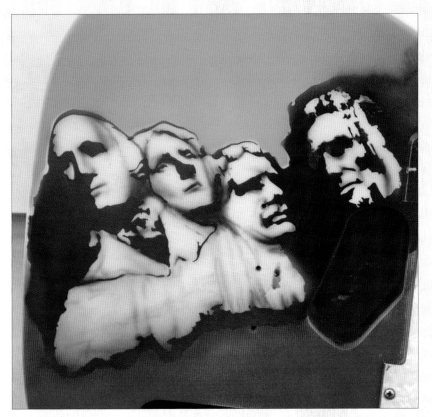

9 Having placed a few drops of transparent black paint into the reservoir of a clean airbrush, spray over the image from a distance of ³⁄₁₆in (5mm) to model the facial features of the faces and surroundings. Study your reference photograph carefully while you perform this step.

10 On a white sheet of paper, draw a simple star using a soft pencil. Cut out the star with a scalpel to create a loose mask.

11 Add some drops of opaque white paint into the reservoir of a clean airbrush. Holding the star mask with your free hand, position it in the blue area of the guitar and spray over the mask. Repeat this step to form a random pattern of stars in both the blue and red areas of the guitar body.

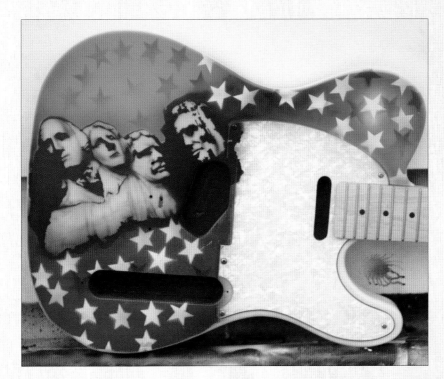

12 Clean the airbrush thoroughly, then place a few drops of violet paint into its reservoir. Use the star mask, as in the last step, to create a random pattern of violet stars in the blue and red areas. Use a 1,000 grit pad to carefully remove any excess paint from the scratchplate.

In a well-ventilated area, spray several light coats of acrylic lacquer over the painted area. Allow time between each application for the paint to dry. This will protect the artwork. If you prefer, a professional body shop will be able to clear coat the surface.

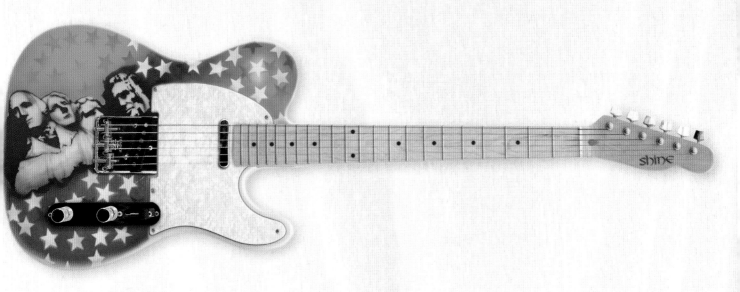

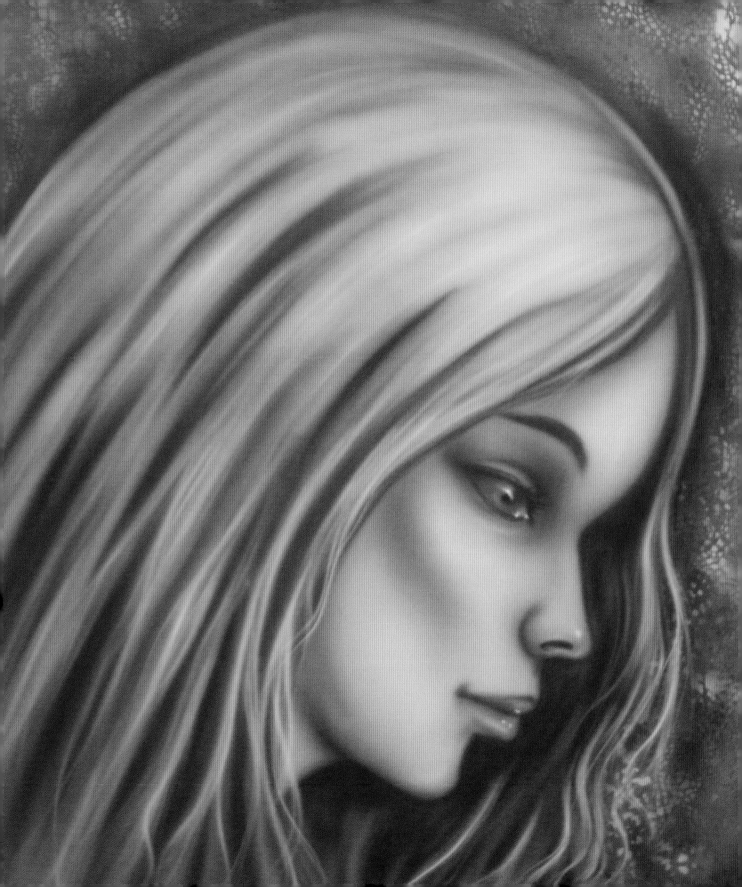

Female Portrait
Coffee table

This is an easy way to jazz up a plain and inexpensive coffee table, turning it into a fine piece of bespoke furniture. It is an ideal piece to add character to your living room and impress your friends.

Tools and equipment

- Coffee table
- Iwata Eclipse airbrush
- Medea Com-Art paints
- JVR Revolution Kolor paints
- Createx Wicked Colors paints
- Masking tape
- Fine lining tape
- Sandpaper (1,000 grit)
- Isopropyl alcohol
- Paper doily
- Acrylic lacquer

2 Mask the sides of the table with masking tape to protect them from any overspray. Using lining tape, create an inner square about ⅜in (10mm) from the edge of the table. Cut the lining tape at each corner with a scalpel to create a border.

1 Rub the top of the table down with sandpaper, being careful not to scratch it. Once the surface is flat and the shine has been removed, wipe off any excess dust. Dip the cloth into isopropyl alcohol and wipe the surface once again.

3 Half fill the airbrush reservoir with opaque white paint and spray the exposed area of the table in light layers.

4 Lightly draw your chosen design onto the table with a soft pencil. Mask the sides of the table with masking tape.

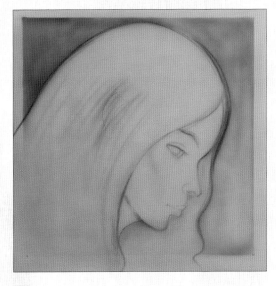

6 Clean the airbrush a second time. Put a few drops of light brown paint into its reservoir and begin to model the face using the original sketch as a guide.

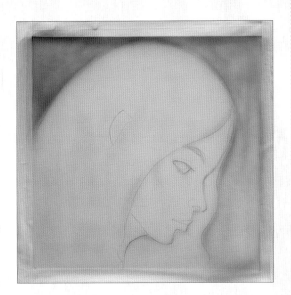

5 Clean the airbrush and flush it through with water. Place several drops of ultramarine blue paint into its reservoir and spray a light mist around the outline sketch.

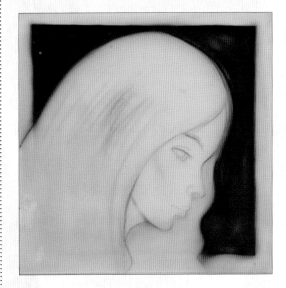

7 With violet paint in the reservoir of a clean airbrush, darken the areas around the face and hair. Once you have finished, remove the masking tape.

8 Place a paper doily over the border surrounding the design. While holding it in position, spray the violet paint over the doily.

10 Clean the airbrush and flush it through, then place drops of opaque white paint into its reservoir. Position the doily in the dark area around the face and hair, then spray over it. Keep moving the doily around and repeating the action until you have covered the whole area.

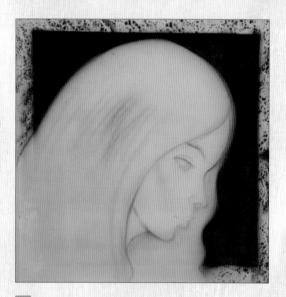

9 Repeat this step across the whole border to create an interesting texture and pattern.

11 Having cleaned the airbrush thoroughly, add a few drops of yellow paint into its reservoir. Spray a light mist over the background, being careful not to spray the face.

13 Next, mix a few drops of yellow ochre with a few drops of dark brown in the airbrush's reservoir. Spray graduated streaks into the hair in several layers to give form to the hair.

12 With a small brush, mix a few drops of light brown and yellow ochre paint in the reservoir of a clean airbrush. Use this to begin to model the hair. Pull a few long lines in the hair at the side.

14 Clean the airbrush and flush it through with water. Use a brush to mix a few drops of yellow ochre with two drops of dark blue paint in its reservoir. Use this to develop the dark areas in the hair (top) as well as the details in the face (bottom). To begin with, spray very light lines, before moving closer to around ⁷⁄₁₆in (5mm) in order to darken the eye and eyelashes and to shade the lips and cheekbone.

15 Clean the airbrush thoroughly. Then with drops of golden yellow paint in its reservoir, spray a light mist over the face and hair.

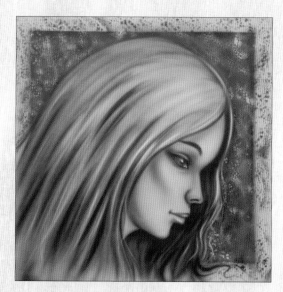

16 Place some drops of transparent white paint into the reservoir of a clean airbrush. Spray fine lines into the hair to help draw out the highlights. At the same time, spray highlights in the eye and the face.

17 Clean the airbrush and flush it through. Place a few drops of vermilion into its reservoir to spray a light mist over the face and lips, creating a warm glow.

19 Clean the airbrush once again. Using a few drops of opaque white paint, spray some more fine lines into the hair to give it greater depth and form.

18 With drops of brown paint in the reservoir of a clean airbrush, spray the dark areas of the hair to add depth to the design. Tone the colour down on the lighter fine lines of the hair by respraying them.

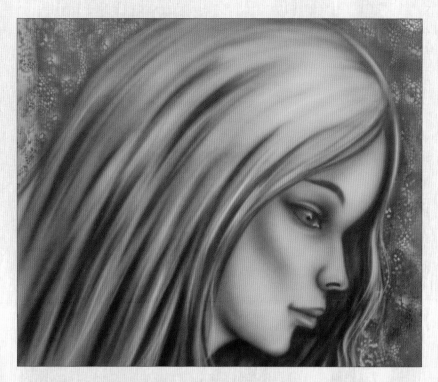

20 Having cleaned the airbrush thoroughly, use a few drops of opaque yellow paint to spray the highlights in the hair.

21 Clean the airbrush and flush it through, then place a couple of drops of opaque white into its reservoir. Use this to spray some more fine lines into the hair, pulling a few of them over to the side of the face.

22 Clean the airbrush a final time, then using drops of violet paint spray a light mist around the top of the head, the top of the eye and over the hair.

Remove the fine lining tape. Spray several light coats of acrylic lacquer over the design, allowing time for the surface to dry between each coat. Both the table and the artwork should now be fully protected.

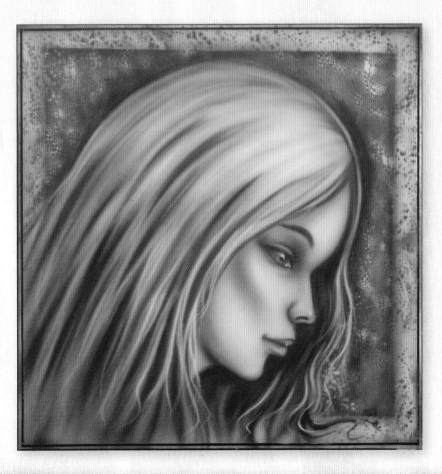

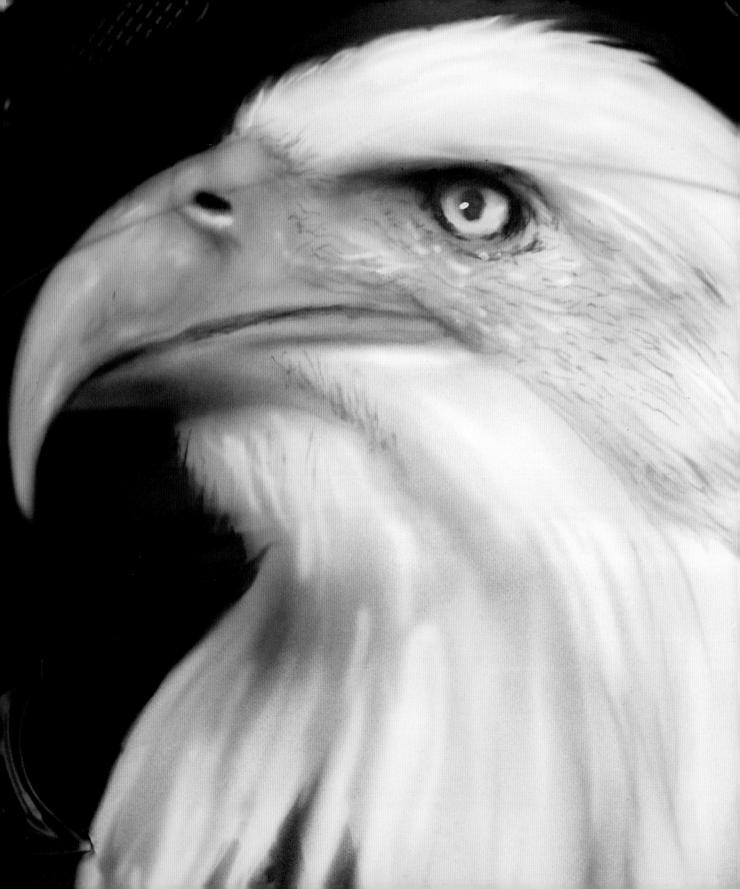

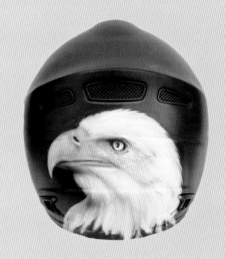

*** ***

Bald Eagle
Motorcycle helmet

The eagle is a symbol of freedom as it soars effortlessly across the sky. When it is painted on a motorcycle helmet, this bird represents the freedom of the open road.

Tools and equipment

- Crash helmet
- Iwata Custom Micron airbrush
- JVR K2 airbrush
- Medea Com-Art paints
- Createx Wicked Colors paints
- Cutting mat
- Scalpel
- Masking tape
- Sandpaper (1,000 grit)
- Tack cloth
- Isopropyl alcohol
- Acrylic lacquer

2 Print the image of the eagle to the size of the artwork you wish to create. With a scalpel cut out the eagle's head.

1 Remove the visor and any other removable parts from the helmet. Mask off the areas not to be sprayed, then rub the helmet with 1000-grit sandpaper until the sheen has gone and the surface appears flat. Wipe the surface with a soft cloth to remove any dust before dipping the cloth in alcohol and wiping away any grease. Finally, spray the area to be airbrushed with acrylic lacquer.

3 Place the eagle mask into position on the helmet, fixing it into position with masking tape. With opaque white paint in the reservoir of the airbrush, spray the exposed area, while using your free hand to ensure that the mask remains in position.

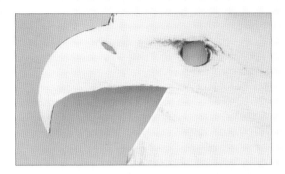

4 Using the scalpel, cut out the eye and beak details from the head mask. Position the mask over the sprayed area of the helmet and fix it in place with masking tape.

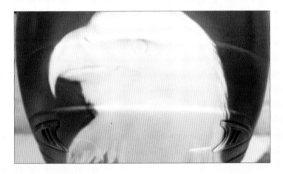

5 Clean the airbrush and flush it through with water. Place drops of Medea transparent black paint into its reservoir and spray a light mist over the cut-out areas.

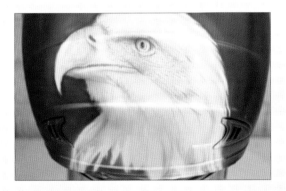

6 Clean the airbrush thoroughly, then place a few drops of transparent smoke paint into its reservoir. Study your reference photograph closely to locate the shaded areas. Spray these areas very lightly to define the shape of the beak, eye and feathers.

TIP

For detailed areas, such as around the eye and beak, spray very fine lines at a distance of ³⁄₁₆in (5mm) from the surface.

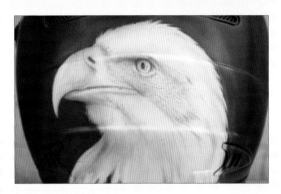

7 Adding black paint into the reservoir of a clean airbrush, spray around the outside edges of the eagle. This will sharpen the edges and clean up any overspray of white paint.

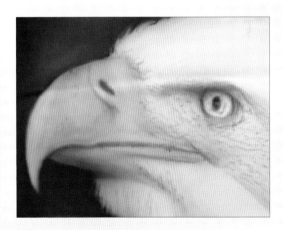

8 Clean the airbrush and flush it through with water. Place some drops of yellow into its reservoir with which to spray the eye and beak. Remember to leave small areas white and to check your reference photograph regularly.

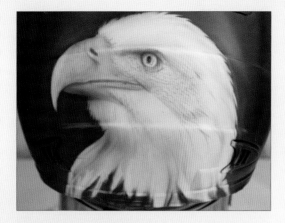

9 Having cleaned the airbrush, place some opaque white paint in its reservoir. Spray over the feathers and around the eyes and neck to make them stand out further and to create a more realistic look.

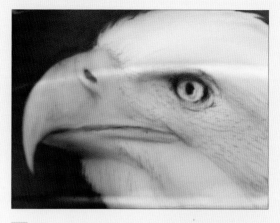

11 Clean the airbrush thoroughly, then add a few drops of black into its reservoir. Spray the area around the eye, beneath it and in its centre. Also spray the mouth line along the eagle's beak.

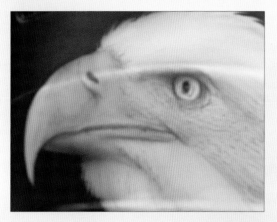

10 Add a few drops of light brown paint into the reservoir of a clean airbrush and use this to spray a light mist over parts of the beak to create texture. At the same time, add shading under the beak, around the eye and on the neck.

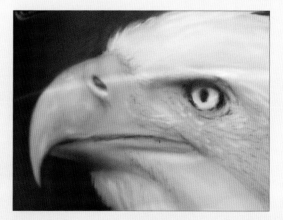

12 Clean the airbrush once again. Place some yellow paint into its reservoir and spray a light mist into the eye and over parts of the beak to define these areas.

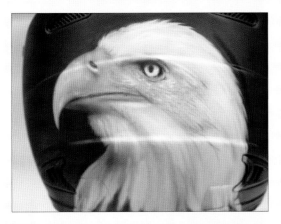

13 Having cleaned the airbrush thoroughly, add drops of opaque white into its reservoir. Use this to spray some very fine lines over the shaded areas of the feathers and on the beak.

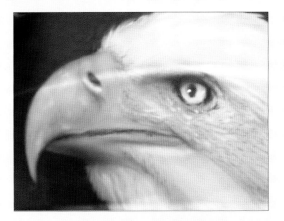

15 Dip the tip of a fine paintbrush into opaque white paint to add a highlight to the eye. Finally, to protect the artwork, a coat of lacquer needs to be applied to the helmet. You can do this yourself, but it is best handled by a professional car body shop.

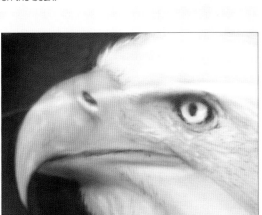

14 For a final time, clean the airbrush and flush it through with water. Place a couple of drops of black paint into its reservoir and spray around the eyes from a distance of around ³⁄₁₆in (5mm) from the surface.

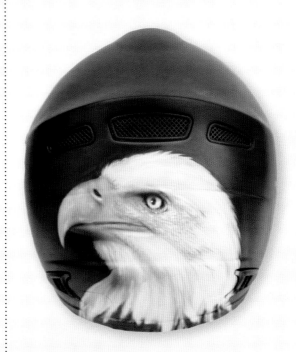

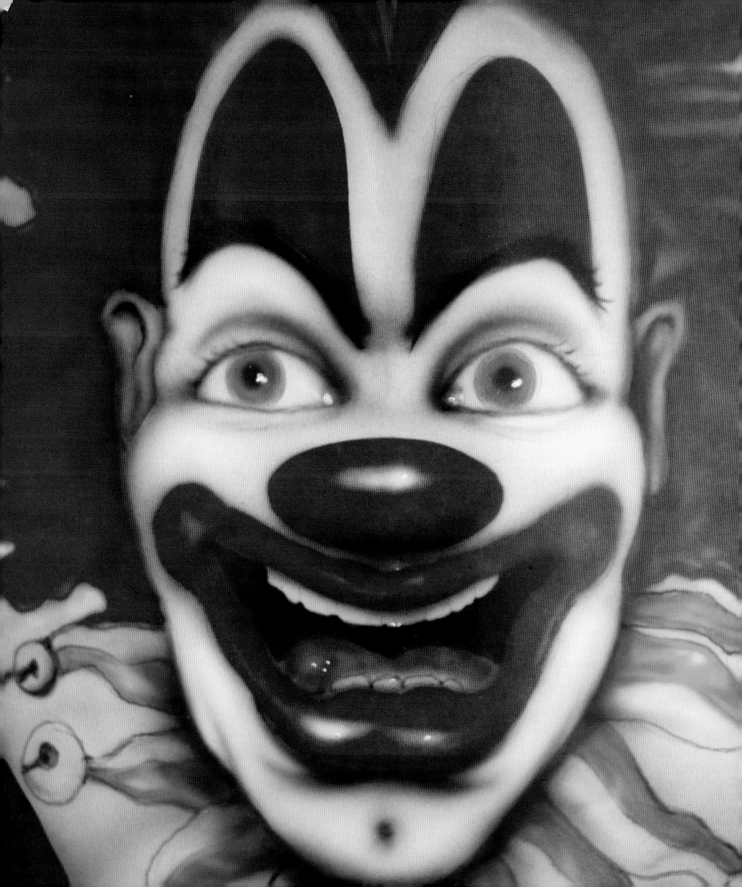

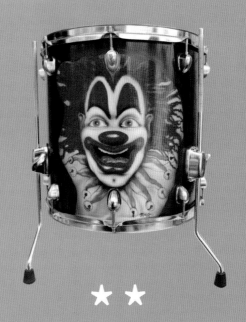

*** ***

Clown Face

Drum shell

The drum has been used by clowns for many years as a prop in circus acts. A clown face is therefore an ideal image to place on a drum and goes well with the energetic character of drummers.

Tools and equipment

- Drum shell
- Iwata Eclipse airbrush
- Createx Wicked Colors paints
- Sandpaper (1,000 grit)
- Masking tape
- Paper for masking
- Fine lining tape
- Tack cloth
- Isopropyl alcohol
- Acrylic lacquer

2 Spray the area with acrylic lacquer, then use fine lining tape to mask out the outline of the area.

1 Gently rub down the area to be airbrushed with the 1,000-grit paper until the shine has gone and the surface appears flat. Using a clean soft cloth dipped in isopropyl alcohol, wipe the area to remove any dust.

3 With masking tape and scrap paper mask the area beyond the lining tape to protect the drum from overspray.

4 Half fill the reservoir of the airbrush with opaque white paint and apply several light coats to the exposed area of the drum. Continue to add coats until the area is a pure shade of white. Then leave it to dry for about 30 minutes.

5 Print the clown design onto A4 paper before cutting out the face with a scalpel. Position the cut-out face onto the drum, holding it down with masking tape. Use a soft pencil to trace around it before drawing the features of the face onto the drum's surface. Be careful not to press too hard with the pencil.

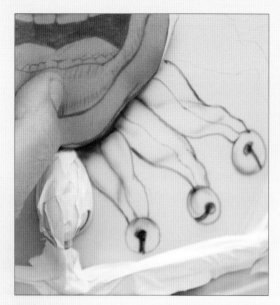

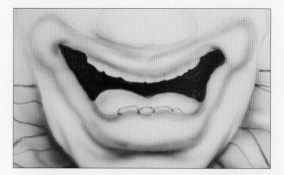

6 Place some transparent black paint into the airbrush reservoir and begin to spray the outline of the collar. Next, use the mask of the clown's face to protect the face while adding shading beneath the chin.

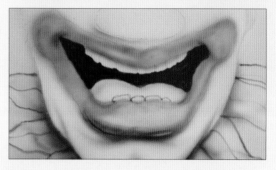

8 Clean the airbrush and flush it through with water. With a few drops of carmine paint in its reservoir, spray the lips from a distance of approximately $^{13}/_{16}$in (20mm) from the surface, building up the colour as you progress.

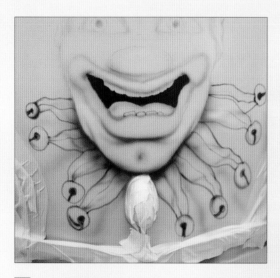

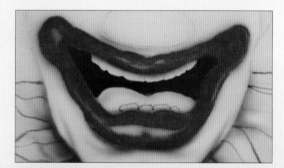

7 Apply a fine mist to shape the lips before blocking in the mouth.

9 Empty the remaining carmine paint from the airbrush before placing a few drops of opaque red paint into its reservoir. Starting with the edges, spray over the lips from a distance of around $^3/_{16}$in (5mm), leaving some areas white for highlights.

10 Using a scalpel, cut the nose out from the face mask. Position it on the drum and spray into the cut-out area, leaving a small area at the top of the nose to add highlight.

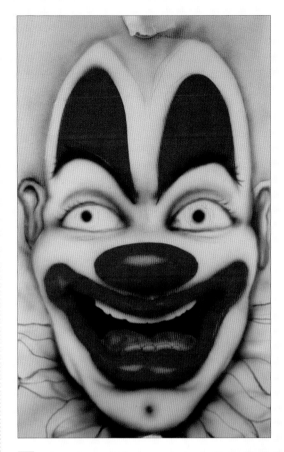

12 Clean the airbrush and flush it through with water. Put some drops of transparent black paint into its reservoir and use this to spray the eyes and the outline of the face. Also, spray a shadow under the nose and over both the eyelids and the chin.

11 In the same way, cut out the red areas above the eyes, place them into position on the drum and spray into the cut-out areas. At the same time, spray the tongue red and apply a fine mist around the face to define the hairline.

Tip

When spraying the outline of the eyelids, spray very close to the surface, about ³⁄₁₆in (5mm) away. Also, create several fine layers instead of just one thick line.

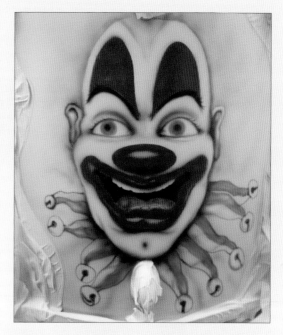

15 Having cleaned the airbrush, place several drops of yellow paint into its reservoir and spray the other half of each section on the collar and the bells. Next, spray a light mist over the eyebrows and around the outside of the clown's face.

13 Clean the airbrush thoroughly before placing some blue paint into its reservoir. Spray half of each section in the collar and spray a light mist onto the bottom of the drum.

14 Use the same paint to spray the eyes.

16 With red paint in the reservoir of a clean airbrush and starting at the peak, spray the hair with fine lines from a distance of around ³⁄₁₆in (5mm). Leave some of the white shining through to give the hair texture.

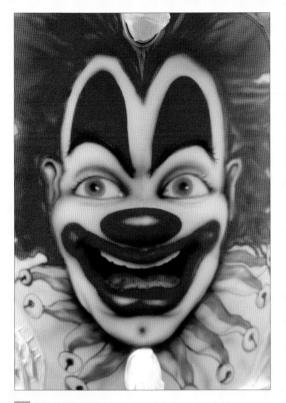

17 Clean the airbrush and flush it through. Add some drops of opaque white paint into its reservoir and use this to spray highlights into the eyes, cheeks, nose and lips.

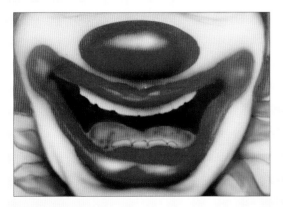

18 Having cleaned the airbrush a final time, place some drops of violet paint into its reservoir and spray a light mist over the shadow areas and into the white areas to tone them down slightly.

19 Dip a fine brush into some opaque white paint and use it to place a dot over the highlight in the clown's eyes, his teeth, nose and lips. In a well-ventilated area, spray several light coats of acrylic lacquer over the painted area to protect the artwork. Allow time between each application for the paint to dry. If you prefer, a professional body shop will be able to clear coat the surface.

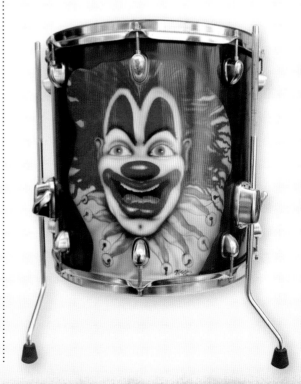

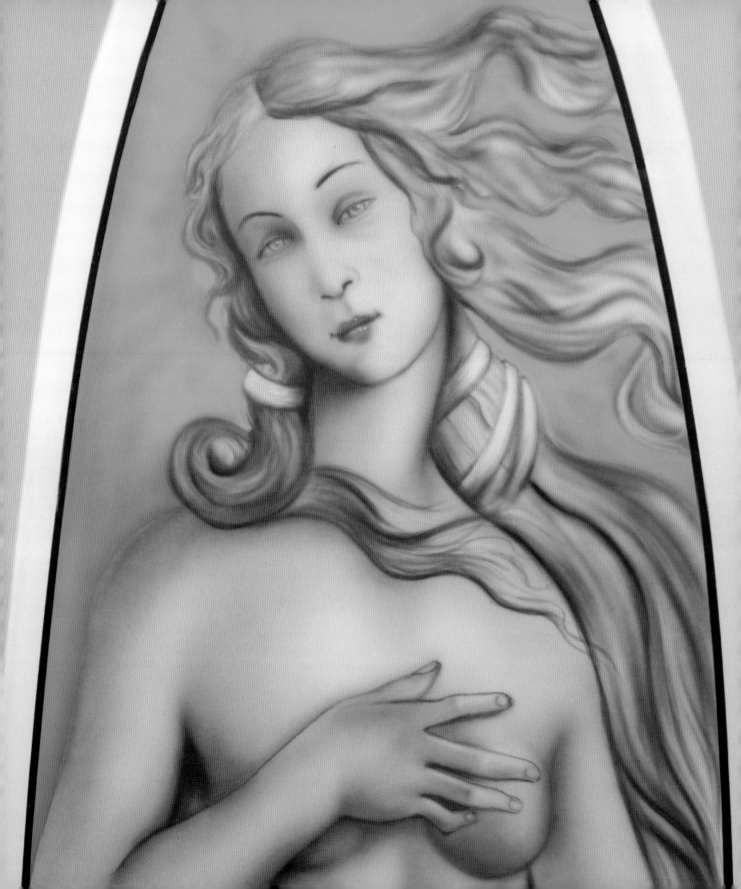

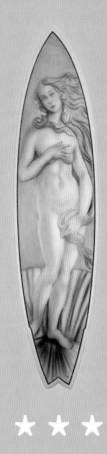

* * *

Goddess Venus

Surfboard

With its smooth lines and elongated shape, the classic surfboard is ideal for a painting of the mystical goddess Venus. Ride the waves in style with a magical image on your board.

Tools and equipment

- Surfboard
- Iwata Eclipse airbrush
- Medea Com-Art paints
- JVR Revolution Kolor paints
- Masking tape
- Fine lining tape
- Sandpaper (1,200 grit)
- Isopropyl alcohol
- Scrap paper
- Soft black pencil
- Projector

2 Use fine lining tape to mask the black outline on the board. This outline will make an ideal border for the final artwork. Go over the edge of the lining tape with masking tape to mask the outer edge of the surfboard. Ensuring that you are in a well-ventilated area and wearing a face mask, spray several light coats of acrylic fixative over the surface of the surfboard. This will help the paint to adhere to the surface when airbrushing. Leave the board to dry for around 30 minutes.

1 Rub down the top of the surfboard with sandpaper, being careful not to scratch the surface. Once it is flat and the shine has been removed, wipe off any excess dust. Dip the cloth into isopropyl alcohol and use this to wipe off any grease.

3 Fill the reservoir of the airbrush with opaque white paint. Spray several coats of paint across the board moving back and forth, overlapping the layers until the board has a smooth coat of white paint.

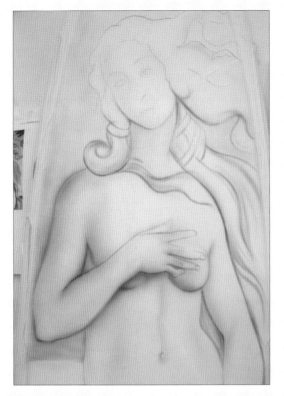

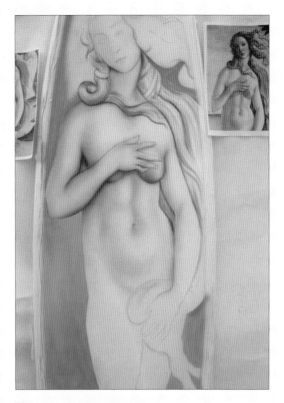

4 Having printed your reference image, project it onto the surfboard and sketch it out using a soft black pencil. Place a few drops of blue paint into the reservoir of the airbrush to spray a light mist around the image, being careful not to spray into the figure's body. Clean the airbrush and flush it through with water. Using light brown paint spray shading into the body to create shape and form. Keep checking your reference image while you do this and try to keep the light areas clean from overspray.

5 Clean the airbrush and flush it through with water. Half fill its reservoir with blue paint, mixed together with several drops of opaque white paint and stirred with a small brush. Use the paint to spray several light layers around the body to the top of the seashell. In the areas nearest to the edge of the body, move in very close to the surface of the surfboard, spraying from approximately ³⁄₁₆in (5mm). As you move further away, spray from a distance of about 2³⁄₄in (70mm) to fill in the surrounding areas.

> ### TIP
> When spraying the fine lines of the drawing, work at approximately ³⁄₁₆–³⁄₈in (5–10mm) away from the surface of the surfboard.

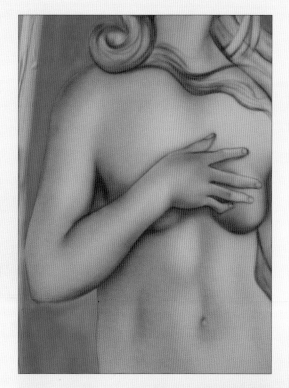

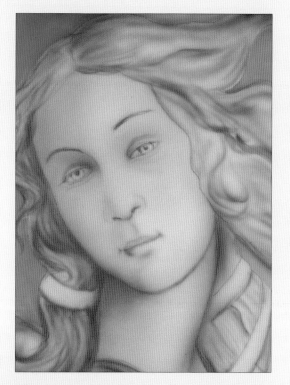

6 With light brown paint in the reservoir of a clean airbrush, continue to build up the various tones of colour in the body, hair and face. While spraying down the side of the body, leave the edge light.

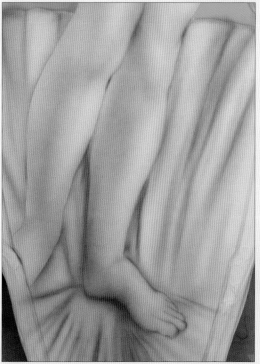

7 Having cleaned the airbrush once again, add some drops of dark brown paint into its reservoir and start to spray in the dark tones of the hair. Also spray in the eye details, creating fine lines, from a distance of ³⁄₁₆in (5mm).

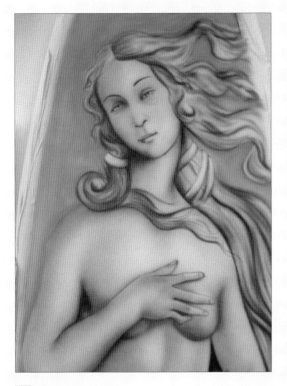

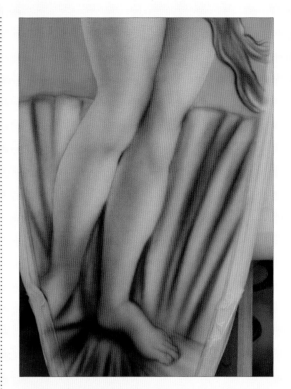

8 Using the same paint, concentrate on adding dark tones to the rest of the body.

10 Having cleaned the airbrush thoroughly, add some drops of opaque yellow paint to its reservoir and use this to spray in the lighter areas of the hair.

9 Clean the airbrush and flush it through with water. Put several drops of golden yellow paint into its reservoir to spray a light mist over the entire body and hair. This will give an even tone to the painting and will also blend with the light brown to create a glowing skin tone.

11 Into the reservoir of a clean airbrush, place a few drops of vermilion paint with which to spray the lips.

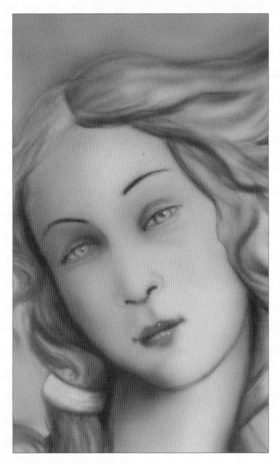

12 For a final time, clean the airbrush and flush it through. With a few drops of white paint in its reservoir, spray the highlights into the eyes. The final step is to spray a light mist over the light areas of the skin.

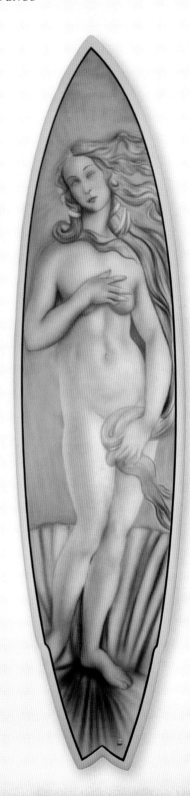

Project index
Textiles

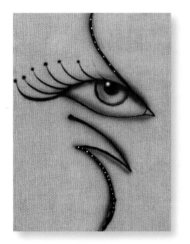

Eye
Jeans

★

page 30

Tie-dye
T-shirt

★

page 36

Peace Dove
T-shirt

★★

page 40

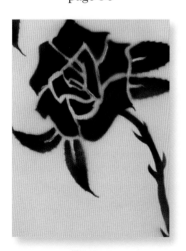

Rose
Handbag

★★

page 46

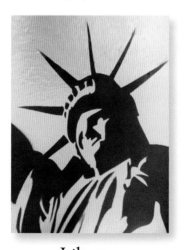

Liberty
Clogs

★★

page 52

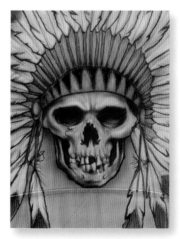

Skull
Leather jacket

★★★

page 56

Canvas and art paper

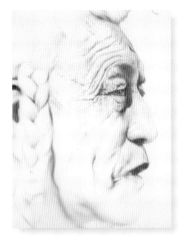

Native American
Art paper
★
page 66

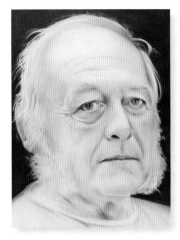

Close Friend
Canvas
★★
page 72

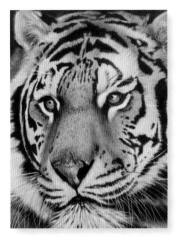

Tiger
Art paper
★★
page 80

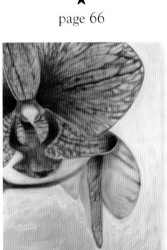

Orchid
Silk canvas
★★
page 88

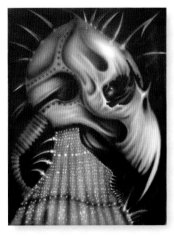

Science Fiction
Canvas
★★★
page 96

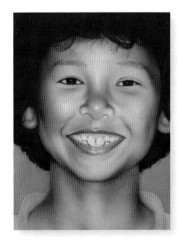

Child's Portrait
Canvas
★★★
page 104

Metals

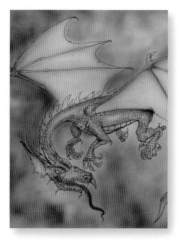

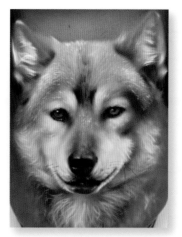

Dragon
Aluminium panel
★
page 118

Wolf
Motorcycle tank
★★★
page 124

Wood

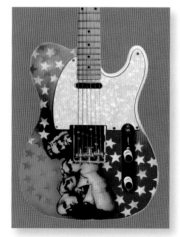

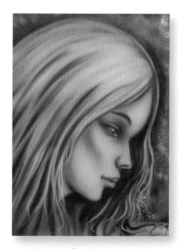

Manga
Skateboard
★
page 136

Mount Rushmore
Guitar
★★
page 142

Female Portrait
Coffee table
★★★
page 150

Composite materials

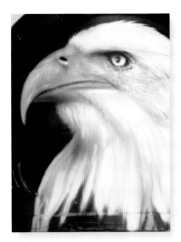

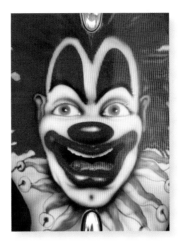

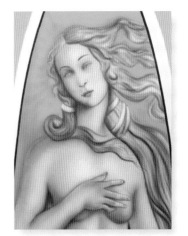

Bald Eagle
Motorcycle helmet
★★
page 160

Clown Face
Drum shell
★★
page 166

Goddess Venus
Surfboard
★★★
page 174

★ Beginners can tackle these projects
★★ Intermediate projects suitable for those with growing skills
★★★ Advanced projects suitable for those with experience

Glossary

Acrylic
Paint created from a synthetic resin containing a pigment suspension. This type of paint is fast drying and forms a plastic coating once dry that is both hard wearing and water-resistant.

Art paper
Type of high-quality paper that has been coated on both sides with a china clay compound or similar to form a hard, smooth surface.

Artwork
A painting, drawing or any other piece of creative work.

Background
The part of the design or image that is behind the main subject.

Block in
The preliminary application of paint where areas of flat colour are applied to blank spaces.

Canvas
A strong, smooth tightly woven fabric designed to allow the application of paint.

Compressor
The machine that supplies air under pressure to the airbrush.

Craft Robo
See 'Plotter'.

Enlarge
A photographic term applied when using an opaque projector to scale up a reference photograph or design to fit a larger canvas.

Freehand
Spraying freehand means using the airbrush without masks.

Frisket
A thin sheet of masking film with an adhesive backing. This can be placed on a suitable support and cut to the desired shape.

Hard mask
Any type of mask that allows the production of very sharply defined edges. These types of masks are firmly attached to the surface of the artwork.

Highlight
The lightest parts of the final artwork, which indicate reflected light from a particular surface. The highlight may be sprayed using opaque white paint or added with a fine-lining paintbrush. These are usually added to the artwork last.

Illustrator (Adobe)
A vector-based drawing program developed and marketed by Adobe Systems. In order to use a plotter to cut out a design, the image needs to be in vector format, which uses mathematical equations to represent the image. Images created in Photoshop, which are raster graphics (represented as an array of pixels), can be converted into vector format using Illustrator.

Loose or soft mask
Any type of mask that is not firmly attached to the surface of the artwork.

Mask
Any material that prevents the airbrush's spray from reaching the artwork surface.

Masking film

A transparent self-adhesive film widely used for masking. Once the backing sheet is removed the film can be placed onto a suitable support and cut with a scalpel into the desired shape. It is easily removed from the surface after use as it uses a low-tack adhesive.

Masking tape

A durable self-adhesive tape that can be used to mask off edges.

Needle

An integral component of the airbrush, which controls the flow of paint and the accuracy of the resulting spray.

Photoshop (Adobe)

An image-editing program developed and published by Adobe Systems. First released in 1990, Photoshop is generally considered one of the best image editing programs for raster graphics (images represented as an array of pixels). (See also 'Illustrator'.)

Plotter

A computer-printing device, such as the Craft Robo made by Graphtec, used for printing or cutting out vector graphics. This device can be used to easily cut complex stencil designs from thin card or masking film. Graphics produced in Photoshop will need to be converted from a raster image into a vector using Adobe Illustrator to allow the software to cut out the design.

psi (pounds per square inch)

The amount of air pressure passing through the airbrush as set on the compressor (1 psi is equivalent to 0.007 bar).

Scalpel

A thin-bladed knife with a very sharp pointed end, which is ideal for cutting out stencils.

Spray

A fine mist of paint and air emitted from the airbrush.

Stencil

A design cut out of a piece of card or other material, which can be used as a mask.

Support

Any material that provides the surface for drawing or painting.

Tack

A term that describes the adhesive quality of a particular material.

Trigger

The component of the airbrush that is operated by the artist to control the flow of air.

Vector

An image format that uses mathematical equations to represent the graphic. Bitmap or raster images produced in Photoshop need to be converted into vectors using Adobe Illustrator to allow the software on plotters to cut out the design.

Suppliers

USA

Art Supply Warehouse
6672 Westminster Boulevard
Westminster
CA 92683
+1 714 891 3626
www.artsupplywarehouse.com

Chicago Airbrush Supply/
Genesis Art Supply
2417 N. Western Avenue
Chicago
IL 60647
+1 800 937 4278
www.chicagoairbrushsupply.com
www.artsupply.com

Coast Airbrush
312 N. Anaheim Boulevard
Anaheim
CA 92805
+1 714 635 5557
www.coastairbrush.com

The Merri Artist
321 NE Baker Street
McMinnville
OR 97128
+1 503 472 1684
www.merriartist.com

UNITED KINGDOM

The Airbrush Company Ltd
Unit 7 Marlborough Road (East)
Lancing Business Park
Lancing
West Sussex
BN15 8UF
+44 (0)1903 767800
www.airbrushes.com

Createx UK
15 Swanstons Road
Great Yarmouth
Norfolk
NR30 3NQ
+44 (0)1493 330100
www.createxuk.co.uk

Graphic Air
Unit 1 Levens Hall Park
Lund Lane
Killinghall
Harrogate
North Yorkshire HG3 2BG
+44 (0)1423 522836
www.graphicair.co.uk

London Graphic Centre
16-18 Shelton Street
Covent Garden
London
WC2H 9JL
+44 (0)20 7759 4500
www.londongraphics.co.uk

ITALY

Airbrush Service
JR Eventi Snc
Via Chiaramone 24/R
16158 Genova
+39 010 61 35 122
www.aerografia.airbrush-service.com

Anest Iwata Europe srl
Corso Vigevano, 46
10155 Torino
+39 011 22 74 438
www.airbrush-iwata.com

AUSTRALIA

Anest Iwata Australia Pty Ltd
Unit 3
10 Boden Road
Seven Hills
NSW 2147
+612 9853 2000
www.anest-iwata.com.au

JAPAN

Anest Iwata Corporation
3176 Shinyoshida-cho
Kohoko-ku
Yokohama 223
+81 (0)45 591 9358
www.anest-iwata.co.jp

Further reading

AGNEW, JOHN, *Painting the Secret World of Nature*, North Light Books, 2001

VERO, RADU, *Airbrush 2 – Concepts for the Advanced Artist,* Watson-Guptill, 1985

ITTEN, JOHANNES, *The Art of Color: The Subjective Experience and Objective Rationale of Color,* John Wiley & Sons, 1997

GIGER, H.R., *H.R. Giger's Necronomicon,* Morpheus, 1993

MEISEL, LOUIS K. AND HELENE ZUCKER SEEMAN, *Photorealism,* Harry N. Abrams Inc., 1989

MEISEL, LOUIS K., *Photorealism Since 1980,* Harry N. Abrams Inc., 1993

Acknowledgements

Many people have helped and contributed to this book. In this brief acknowledgement section, I want to thank as many of them as possible.

My son, Marco Uccellini for all his hard work in helping produce this book, including his photography, project advice and copywriting.

My good friend, Giulliano Rapetti for providing us with his brand of equipment and paint.

John Ogden and Josiah Wicks, for kindly agreeing to have their portraits painted for this book.

Lisa Munroe and Alex Medwell, from the Airbrush Company, for providing equipment used in the production of this book.

Ernst-Otto Böttger, from Createx, for supplying Wicked Colors paint.

And finally, my warmest thanks to my wife, Trisha, for her help with the text, and her encouragement and patience during the production of this book.

Index

Projects are indicated by page numbers in **bold.**

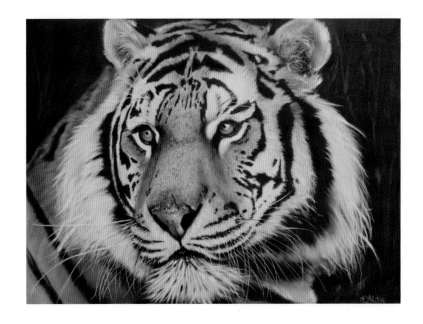

To place an order or to request a catalogue, contact: GMC Publications Ltd.
Castle Place, 166 High Street, Lewes, East Sussex, BN7 1XU, United Kingdom
Tel: +44 (0)1273 488005 Fax: +44 (0)1273 402866 www.gmcbooks.com